104

MOTION
GRAPHICS

GRAPHIC DESIGN FOR BROADCAST AND FILM

ROCKPORT

MOTION GRAPHICS

GRAPHIC DESIGN FOR BROADCAST AND FILM

STEVE CURRAN

GLOUCESTER MASSACHUSETTS

ROCKPORT PUBLISHERS

First published in the
United States of America by:
Rockport Publishers, Inc.
33 Commercial Street
Gloucester, Massachusetts
01930-5089
Telephone: 978.282.9590
Facsimile: 978.283.2742
www.rockpub.com

ISBN 1-56496-646-1

Book Design:
Otherwise, Inc. / Chicago, IL

Cover Design:
Hatmaker / Watertown, MA

Printed in China

329116

Back Cover Images (from
top to bottom, left to right):

Hatmaker, Cinemax
see page 61;
FUEL, ESPN: X-Games
see page 43;
R/Greenberg Associates,
Island of Dr. Moreau
see page 162;
FUEL, MTV: "The Cut"
see page 45;
3 Ring Circus, Target
see page 14;
R/Greenberg Associates,
Seven
see page 170;
Global Japan, SF
see page 52;
yU+ co.,
Dolby Laboratories:
Rain
see page 174

This book is dedicated to
Robert and Mary Curran,
producers of EIGHT CHILDREN.

That's not a film title; they
really produced eight children.

CONTENTS

INTRODUCTION

The term *motion graphics*, in the context of this book, refers to the art of communication design
for broadcast and film. Firms practicing in this field vary considerably in size and style; those included
here range from a one-man, part-time film-title designer to a 150-person broadcast design company.

While the computer's impact on design firms' work and business is too great not to be discussed,
the focus of this book is on great ideas and brilliant executions. As Seth Epstein of FUEL put it:
"If I thought I could do great work using a club, that's what I would use." The design solutions
featured in this book were conceived and created by teams of individuals obsessive and passionate
about solving problems through design. Far more important than the technology involved is the
brilliant strategy, inspired visualization, and, most important, the gut instinct that drives the work.

Groups like the Broadcast Design Association (BDA) and Promax have done an outstanding job in
building a community for this growing industry with newsletters, award shows, publications, and
Web sites. But a vast number of graphic designers are unaware of the origins of the exciting work
they've seen in movies and on television. The firms chosen for inclusion in this book represent a
broad range of the best firms, but the list is by no means complete. Many more firms and individuals
exist around the world that do great work in television and film than can be included in one book.
I think you'll find a collection of incredibly talented individuals, from both a creative and a business
perspective, who have dedicated their careers to doing what they love and to bringing others
along with them.

Steve Curran

THE BIG

More and more, every day, graphic design refuses to sit still. The world's central nervous system, interconnected nerve tendrils of cable, telephone lines, and satellites, is buzzing with the adrenaline of commerce, information, and entertainment. The role of visual communicators who help define, envision, and deliver these messages has never been more important and increasingly becomes more challenging.

The relentless onslaught of media and messages, combined with a shortened audience attention span, has raised the stakes on developing effective and evocative communication design and branding that cuts through the clutter. The hyperactive arenas of commerce, information, and entertainment are at the mercy of the moment—the critical seconds in which a viewer decides whether or not to change a channel, exit a Web site, or, when watching a trailer, to see a film. These are the moments that are entrusted to the strategy, creativity, and craft of broadcast designers, film title designers, and animators skilled in the art of motion graphic design.

PICTURE

Motion graphics is a term used to describe a broad range of solutions that graphic design professionals employ for creating a dynamic and effective communication design for film, television, and the Internet. It combines talents such as design, filmmaking, writing, animation, information architecture and sound design into a profession that Billy Pittard, president of Pittard Sullivan, has referred to in ads for the BDA as "the extreme sports decathlon of design."

In the last few years, the demand for Internet design has introduced a large number of graphic designers to the world of motion graphic animation. The emerging generation of designers is the first to have received multimedia and animation training as an integrated and important part of the design school curriculum. Today's design school graduate has no meaningful recognition of history B.C. (before cable) and is too young to remember when a twelve-by-twelve-inch vinyl record sleeve was the ultimate graphic design billboard. For this MTV-weaned generation of creative talent, designing animation for broadcast or film is the holy grail of graphic design opportunity.

TELEVISION

BLAME IT ON MTV

Before the advent of cable television in the 1980s, on-air graphics of the Big Three networks had grown cold, corporate, and unimaginative. Flying metallic logos and staid solutions defined on-air graphics; they were products of technology and corporate culture more than of creativity and talent. Because the networks were battling for the eyeballs of the lowest common denominator, they had developed department store personalities—all things to all people.

Then MTV arrived. Like a rebellious kid, it broke rules, turned up the volume, and demanded attention. MTV ignored all conventions of consistency in corporate identity. Instead, it built an on-air look alternately loud, smart, funny, strange, edgy, and sometimes stupid—but, most important, right on target. MTV was free to be as raucous, energetic, and unpredictable as was the audience it sought to attract. With the creative advantage of marketing to a specific audience in a stand-alone category, MTV showed the way for future category-killers such as VH1, Nickelodeon, CNN, and ESPN. The narrow-casted TV universe had arrived.

Narrowcasted channels not only opened up exciting creative opportunities in network branding, they also freed Madison Avenue's creative limitations. Advertising concepts that would have been too "nichey" for network television now could be effectively placed on the appropriately defined cable channel of choice. This growth of markets prompted a thirst for strategic specialists to make sense of the new venues. Burgeoning design firms like Pittard Sullivan developed new, flexible, and compelling visual languages that served to package and deliver these venues to the audience and, in turn, deliver the audience to the advertisers. By necessity, the quality of this work must meet and, in some cases, surpass the production values of the networks and channels where they are shown.

These firms are masters of the short film. They are responsible for the animated identities, show openers, interstitials, bumpers, and teasers that make up the network's identity. Increasingly, the broadened bandwidth of digital delivery has created an appetite for new channels that outpaces the creation of original programming. For many new networks, the on-air branding itself is the only original content on the network, further blurring the line between branding and entertainment. With the promised future of a merged television and computer, the breakthrough graphics that help define the converged medium may come from the firms found here, from an Internet design firm, or perhaps from some yet-unknown talent, still in art school somewhere. **Stay tuned...**

SHOWTIME

NO LIMITS

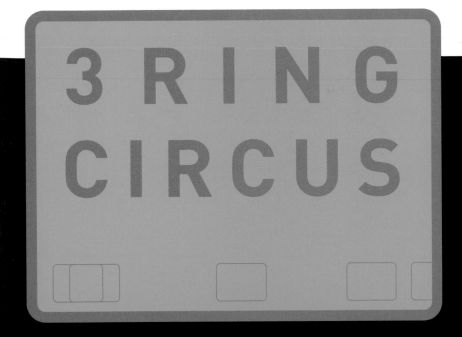

3 RING CIRCUS

UNDER THE BIG TOP

When John Sideropolous and Jeff Boortz left Pittard Sullivan in 1994, they had a clear vision for the firm they wanted to build. John recalls, "We felt that if we could bring together top-level creatives in a nurturing environment where we controlled the size, not only would it be a cool place to work but we could definitely do some great work."

3 Ring Circus, the firm they founded, certainly lives up to that vision—it is responsible for some of the most original and visually arresting branding work on television today. 3 Ring Circus has perfected the high-wire balancing act of producing innovative creative while working with a net of well-grounded strategy and research.

Critical to maintaining this balance is the partners' commitment to controlling the growth of the company in order to maintain the ideal creative environment.

"We believe we should remain a midsize company; it becomes too hard to manage the creative process with so many employees," says John. "We strongly believe in the creative and collaborative process, and in order to do that, you have to avoid unmanageable growth.

"The reality is that there is a limited number of top-notch creatives who think strategically, so it is difficult to grow and add people who live up to our standards. There are no prima donnas here, and we haven't tiered the company with too many layers. Our goal was to be leaner, much more competitive, and a lot more efficient. We make ourselves totally accessible to our clients. People enjoy working with us because of our relaxed and personal environment."

ZDTV — "COMMUNICATION NATION"

ZDTV is a channel focused on computers, technology, and the Internet. The thought of viewers lost in the sometimes daunting new realm of Internet media led to a series of on-air spots that offer guidance and help through a variety of surreal worlds—layered and textural entertainment landscapes conceived specifically for ZDTV. In each spot, the viewer is enticed into the new world and led through the communications landscape by ZDTV. Each space explores the unexpected to counter the common perception of computers as cold and sterile. Rich color and surreal qualities lend the channel a warmer, more human identity.

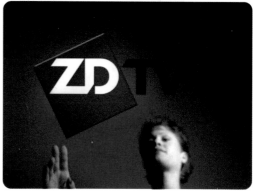

CREATIVE DIRECTOR / DESIGNER / DIRECTOR > Elaine Cantwell **DESIGNER >** Nick DiNapoli
DIRECTOR OF PHOTOGRAPHY > Andrew Turman **HENRY ARTIST >** Scott Milne **EXECUTIVE PRODUCERS >**
John Sideropoulos, Lori Pate **PRODUCER >** Johnny Wow

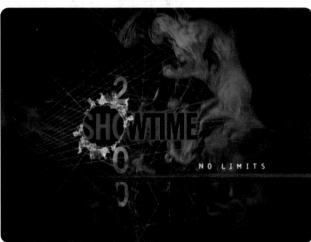

SHOWTIME NETWORKS — "NO LIMITS 2000"

The design for the Showtime 2000 image campaign utilizes light as a source of uncontrollable energy that culminates in explosions of illumination. The package expresses the concept of energy in motion to communicate the concept of "No Limits," which can be taken into the year 2000 and beyond.

CREATIVE DIRECTOR / DESIGNER > Elaine Cantwell **DIRECTOR OF PHOTOGRAPHY >** Dan Schmidt **COLORIST >** Rob Sciarrata **TYPE ANIMATOR >** Matthew Hall **HENRY ARTIST >** Mike Davis **EXECUTIVE PRODUCER >** John Sideropoulos **PRODUCER >** Patty Kiley

KERMIT CHANNEL — "EXPECT THE UNEXPECTED"

The identity that 3 Ring Circus created for the family-oriented Kermit Channel focuses on good storytelling and the element of surprise. It is rich with twist and turns, juxtapositions, quirks, and impulses. At times the identity can be educational, sometimes humorous, but it is always entertaining.

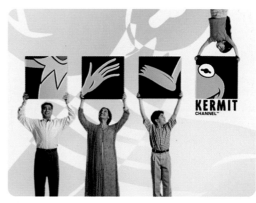

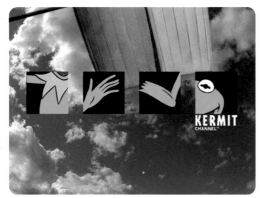

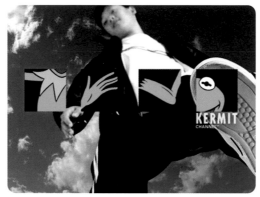

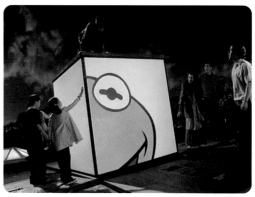

CREATIVE DIRECTOR / DESIGNER > Jim Kealy **DESIGNER >** Matthew Hall **ART DIRECTOR >** Joaquin Grey **DIRECTOR OF PHOTOGRAPHY >** Andrew Turman **HENRY ARTISTS >** Jim Kealy, Scott Milne **TELECINE >** Dave Hussey **EXECUTIVE PRODUCER >** John Sideropoulos **PRODUCERS >** Eric Black, Brett Battles .

DISCOVERY SCIENCE CHANNEL — "THINK TANK"

The "Think Tank" concept was created to entice viewers to experience the thrill of scientific exploration and discovery—the content of the Discovery Science Channel—regardless of their level of enthusiasm for science. The "Mousetrap" ID makes the complex scientific theory of fission entertaining, playful, and almost rebellious. The complete package uses a wide yet consistent palette of colors to further represent the various corners of science.

CREATIVE DIRECTOR > Jeff Boortz **ART DIRECTOR >** Joaquin Grey
DIRECTOR OF PHOTOGRAPHY > Andrew Turman **HENRY ARTIST >** Jeff Boortz
EXECUTIVE PRODUCER > Lori Pate **PRODUCER >** Patty Kiley

A & E — "ESCAPE THE ORDINARY"

The spots that 3 Ring Circus developed for A&E, the arts and entertainment cable channel, work the theme "Point of Reflection" to capture the extraordinary personalities the channel presents. The firm combined elements of original live action, programming clips, and graphic elements to create a modular design that focuses on moments of inspiration.

CREATIVE DIRECTOR / DESIGNER / DIRECTOR > Elaine Cantwell **DESIGNER >** Matthew Hall **ART DIRECTOR >** Joaquin Grey **DIRECTOR OF PHOTOGRAPHY >** Patrick Loungway **HENRY ARTIST >** Scott Milne **TELECINE >** Dave Hussey **EXECUTIVE PRODUCER >** Mick Ebeling **PRODUCER >** Eric Black

ONCE TV — "AWAKEN YOUR SENSES"

Once TV is a public-access television network in Mexico. For a series of new identity spots, 3 Ring Circus focused on the sensory experience. Each ID expresses a different aspect of the Mexican love of color, passion, texture, and emotion through the distinction of the senses, vision, sound, taste, and touch. The choreographed interaction of the model with other elements communicates the theme of the spot.

CREATIVE DIRECTOR > Elaine Cantwell **DESIGNER** > Alexei Tylevich **COLORIST** > Dave Hussey **HENRY ARTIST** > John Eineigl **PRODUCER** > Patty Kiley **EXECUTIVE PRODUCER** > John Sideropoulos

For discount merchandise chain Target's thirty-second national spots, 3 Ring Circus focused on the idea of selling a lifestyle, an attitude, and a way of living. The designers used the familiar Target bull's-eye everywhere in the spots as an icon representing style, sophistication, and contemporary living. The bull's-eye is a simple vehicle that distinguishes Target as a place for fun, attitude, and style.

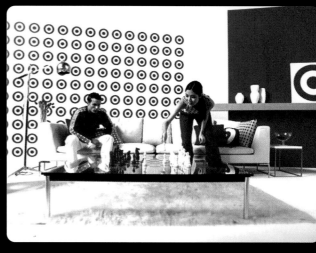

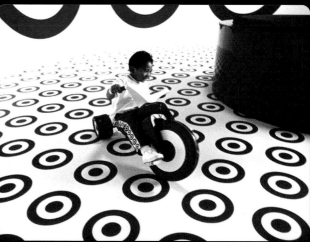

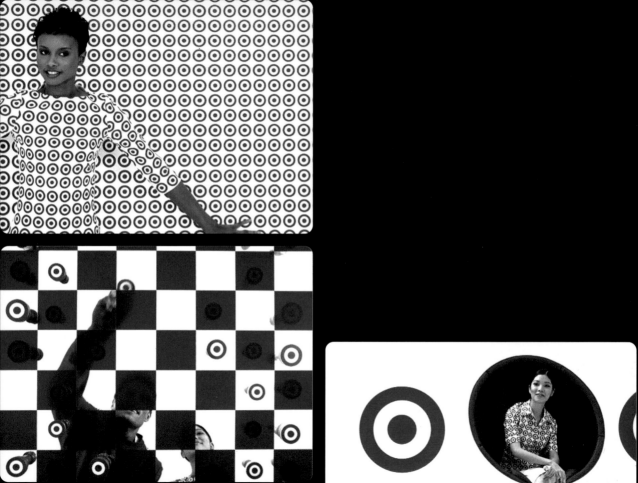

TELEMUNDO — "THE BEST OF BOTH WORLDS"

3 Ring Circus positioned Telemundo, a U.S. Spanish-language television network, as "The Best of Both Worlds," with the network logo interpreted as a portal through which viewers connect with the varied elements of the Latin community in the United States. The spots for Telemundo portray the network as warm, natural, inviting, and accessible, the hub of a wheel that unites the diverse ages, styles, and cultural heritages of the Latin American community.

CREATIVE DIRECTOR / DESIGNER / DIRECTOR > Jeff Boortz **DESIGNER >** Nick DiNapoli
ART DIRECTORS > Joaquin Grey, Keith Mitchell **DIRECTORS OF PHOTOGRAPHY >** Jeff Venditti,
Chris Baffa, Rhet Bear **HENRY ARTISTS >** Jeff Boortz, Scott Milne **TELECINE >** Dave Hussey
EXECUTIVE PRODUCER > John Sideropoulos **PRODUCER >** Eric Black

TRAVEL CHANNEL — "A SENSE OF PLACE"

3 Ring Circus developed "A Sense of Place" as the conceptual platform for the Travel Channel identity.
The concept is to explore the cable channel as a place where enthusiasts not only obtain information but also
are immersed in the experience of travel. To visualize this concept, 3 Ring Circus focused on the essentials of
travel in an experiential fashion. The simplicity of the visual approach furthers the sense of place as a moment
in time, as opposed to a geographical location.

CREATIVE DIRECTOR / DESIGNER / DIRECTOR > Elaine Cantwell **DESIGNER** > Mike Jones **ART DIRECTOR** > Joaquin Grey **VISUAL EFFECTS** >
Nicole Tidwell **DIRECTOR OF PHOTOGRAPHY** > Jeff Venditti **HENRY ARTIST** > David Newburger **EXECUTIVE PRODUCER** > Lori Pate
PRODUCER > Patty Kiley

THE ATTIK

COOL INCORPORATED

In thirteen years, The Attik has grown from a two-person shop to a global operation with over 150 employees with offices in Huddersfield (U.K.), London, New York City, San Francisco, and Sydney. The Attik has become internationally recognized in design for its edgy, hypnotic, techno-fueled imagery that taps directly into the zeitgeist of youth culture.

The foundation and reputation of the company had been built on print design. Two years ago, however, an unexpected muse inspired the vision that cofounder James Sommerville now holds for the future of his firm. "An [advertising agency] art director who was looking for a way to finish an ad he was working on was looking at our print work and telling us how great it would be to see it move. We executed a really cool finish to his commercial, and suddenly we had this new canvas to experiment and play on." Sommerville was surprised at how much opportunity motion graphic design offered and was turned on by the creative potential. The New York office now dedicates 90 percent of its efforts to broadcast, commercial production, and film. Soon, a majority of the firm's work worldwide will be in this area.

While The Attik is certainly a favorite among young designers for its cutting-edge design,
Sommerville is aware that broadcast industry veterans seem eager to dismiss the firm's work
as all style and no strategy. To this he responds:

"What they don't see is the underlying strategic thinking in our creative. The thing with strategy is you can buy it. I don't think
you can buy quite as easily a good creative team. No disrespect to anyone who does strategy, but it's like riding a bike—
you can learn to do it. With creative, it's more like you can draw or you can't draw. At the end of the day, as long as the strategy
is right and the homework has been done, what hits the screen is what the consumer reacts to. It's the look of it. We are
turned on by the point of purchase in the window, which pulls us into the shop, and which maybe forces us to buy a product."

He sees the effect of firms like The Attik on the broadcast design industry as a two-way street. "It will be interesting to see
how these design firms change. Will the younger shops who look up to larger firms become more strategic, or will the larger
firms strive to be become cooler, like boutiques? I think that there will be an element of both."

M T V — "x" / "s"

For the launch of MTV's digital suite, a new set of channels created exclusively for digital cable, The Attik produced a series of twenty ten-second IDs. For MTV "X," a rock channel, the firm pursued a cold, sharp, aggressive, darker vision for the channel. For MTV "S" an exclusive, Latin orientated video channel, they structured a more organic, rhythmic and sensual palette.

GROUP CREATIVE DIRECTOR / DIRECTOR > James Sommerville **CREATIVE DIRECTOR / DIRECTOR >** Simon Dixon
EXECUTIVE PRODUCER > William Travis **SENIOR PRODUCER >** Jim Moran **ASSOCIATE PRODUCER >** Claire
Plaskow **CLIENT >** Nigel Cox-Hagen, creative director; Mike Engleman, unit manager

COLUMBIA TRISTAR—IDLE HANDS

The Attik produced the live action and graphics for the title of a trailer for the film *Idle Hands*, a teen-oriented comedy film that spoofs horror movies. With a combination of live action, stop-motion animation, agitated typography, and deep reddish tones, the animation hints of murder without being either literal or gruesome.

DIRECTOR / CREATIVE DIRECTOR > Simon Dixon **EXECUTIVE PRODUCER >** William Travis
DESIGNER > Monica Perez **DESIGNER >** Stephan Burle **PRODUCTION COMPANY >** Jennifer Todd and
Susan Todd, Team Todd Productions

ADIDAS — "PERFORMANCE"

For Adidas, makers of popular athletic shoes, The Attik created a sixty-second promotional spot
designed around the themes of motivation and performance.

This high-energy video quickly intercuts male and female athletes with graphically driven
backgrounds. The "Performance" ad challenges viewers via messages that type on screen as the
scenes change. The video combines a mixture of 35mm and 16mm footage, with pre-built animation
and hand-generated graphics.

DIRECTOR / CREATIVE DIRECTOR > Simon Dixon EXECUTIVE PRODUCER > William Travis DESIGN DIRECTOR >
Monica Perez CLIENT > Adidas > Andrews Jenkins, director; Devon Moore, art director; Brad Goldthwaite, producer

EIDOS INTERACTIVE — VIDEOWALL

The Attik created a videowall projected image piece for Eidos Interactive, a developer and publisher of interactive entertainment. The designers combined a seamless train of graphics that included gaming icons, urban textures, game characters and typography to create a sense of high energy and excitement. The graphics were used in combination with live-action and video-game footage to break up the videowall and to carry the viewer through a nine-minute experience of Eidos.

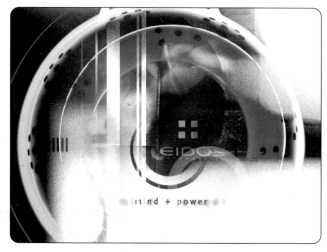

PRESIDENT / EXECUTIVE PRODUCER > William Travis **CREATIVE DIRECTOR / DIRECTOR >** Simon Dixon **DESIGNERS >** See Hor, Jon Thompson, Jayson Tang **3-D DESIGNER >** Cristian Perez **PRODUCER >** Scott Boyajan **CLIENT >** Eidos Interactive > Sutton Trout, executive creative director **ONLINE EDITOR >** Tony Mills, Varitel Editorial **OFFLINE EDITOR >** Bonnie Hawthorne, Varitel Editorial **MUSIC >** Everclear

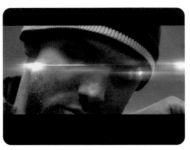

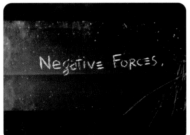

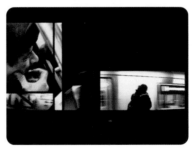

THE ATTIK— NEGATIVE FORCES, WITCHCRAFT, AND IDOLATRY

In an experimental short film designed to showcase the diverse talents of The Attik, *Negative Forces, Witchcraft, and Idolatry* is a visual diary of New York's subway system. Two teams with disguised cameras spent twenty-four hours in New York's underground. The design firm compiled nine hours of footage and edited it down to seventeen minutes. The gritty and unpredictable people-focused film is enhanced by a strong use of black-and-white footage, variable pacing, and sound design.

DIRECTOR > James Sommerville **EXECUTIVE PRODUCER >** Jim Moran **PRODUCER >** Claire Plaskow
CAST > The Attik New York Designers **EDITOR >** Oliver Wicki, Blue Rock Editing **POSTPRODUCTION**
ARTIST > Kieran Walsh, Manhattan Transfer **SOUNDTRACK >** Gareth Williams, JSM Music

COMEDY CENTRAL—LOGOS

For a series of animated ten-second spots, The Attik brought the traditionally 2-D Comedy Central logo into the third dimension. The firm chose to explore and experiment with the properties of liquid, rubber, and fire when subjected to extreme environments. The variously rotating, twisting, bending, or bouncing Comedy Central logo brands the network while offering viewers new perspectives on the graphic identity.

CREATIVE DIRECTOR > James Sommerville EXECUTIVE PRODUCER > Jim Moran DESIGN DIRECTOR >
Tina Lauffer DESIGNER > Garry Jacques PRODUCER > Claire Plaskow CLIENT > Comedy Central >
Maria Danar, creative director / vice president of On-Air Promotions; Liz Blumenkrantz, producer

HBO — "SATURDAY NIGHT GUARANTEE"

The Attik created a sixty-second updateable graphic module that enables HBO, a premier cable channel, to promote four weeks of programming at a time. The design team shot multifiltered in-camera lens and light effects to brand the HBO logo and titles while utilizing live-action train footage and animated negative space to create an overall sense of grandeur.

CREATIVE DIRECTOR > James Sommerville EXECUTIVE PRODUCER > Jim Moran
DESIGN DIRECTOR > Tina Lauffer CLIENT > HBO > Mark Davidson, executive producer;
Andy Verderame, Steve Newman, managers

BRIAN
DIECKS
DESIGN

AN INDEPENDENT SPIRIT

A few years back, Brian Diecks received a call out of the blue that would help carve the niche for his future firm. He was working as a freelancer when a new network, the Independent Film Channel, asked him to pitch the network launch. "I thought that they might not understand that I was a one-man shop, but as it turned out, that's one of the reasons they wanted me. They felt that, true to the spirit of independent film, they wanted a truly independent, outsider approach."

With nothing to lose and everything to gain, Brian pushed the concept as far as he could and created a stunning, edgy on-air look that not only won the pitch but also went on to win awards, accolades, and the respect of prospective clients and peers alike. Soon he found himself buying Macintoshes and building a business.

As the industry became aware of his work for the Independent Film Channel, clients started coming to Brian for a different, riskier look than the designs being produced by more established peers. "A lot of times, in a pitch, we'll find ourselves in the company of a few of the more tried-and-true broadcast identity firms, but we'll be the firm that they are looking toward to bring the unexpected solution." Brian hears it many times from clients: "Your reel is different; that's what we want." According to Brian, a client's genuine desire for something different bodes well for the firm in the pitch and in the client-agency relationship to follow.

The close tie of the firm's image and reputation to Brian's own work and style is one reason why Brian limits the number of employees to twelve to fourteen people; with a group this size, he can be involved intimately with all the studio's work. "We want to stay at a size that we feel best serves the mission of doing great work and not grow simply for the sake of growing."

The challenge for a small firm is to balance client expectations and a good business model; the availability of tools has led to more small shops, which have generated unrealistic expectations for faster and cheaper design at the expense of a profitable business model. The firm's response has been to focus on building longer-term and, ideally, larger relationships with clients. The firm also leaves individual projects to the competitive fray. "It's important for a firm to be able to bend and be flexible," says Brian, "but when it comes to unrealistic expectations, we are starting to say 'no' more often than not."

ESPN — "DROP INTO" X-GAMES CHALLENGE

The objective for the firm's designs for ESPN's "Drop Into" X-Games Challenge was to create a high-energy, visually arresting spot to promote the ESPN sponsored contest, where the winner would win a trip to San Francisco, host city of the games. The winner would then attend sky-diving classes and be "dropped into" the X-Games via live broadcast. Elements that reflected light and footage of skydivers were intercut frenetically to depict the speed of a skydiving drop and the intensity of the X-Games. Bold, clean type urged viewers to sign up and win.

CREATIVE DIRECTOR / DESIGNER > Brian Diecks
PRODUCER > Victoria Michael **ANIMATOR >**
Christopher O'Neil **CLIENT >** ESPN > Ron Finkelestein,
Director of Creative Services

ESPN SPORTSCENTER—
INTERNATIONAL IMAGE CAMPAIGN

This image campaign sought to raise worldwide awareness of the popular domestic television show *ESPN SportsCenter* while highlighting the range of sports covered by ESPN International. The firm developed visuals to attract and excite viewers of many nationalities and, in turn, brand the show.

CREATIVE DIRECTOR > Brian Diecks **PRODUCER** > Victoria Michael **DESIGNER** > Amanda Hayes
ANIMATOR > David Kelley **MUSIC** > Gary Pozner **CLIENT** > ESPN > Andy Bronstein

ESPN — WNBA IMAGE CAMPAIGN

The goal was to create a series of image spots to promote the newly created Women's National Basketball League (WNBA) and its impending first season. The firm took on the challenge of creating the spots without footage, interviews, or relevant content. To convey the excitement of opening day, it chose to rely instead on the auditory sensations of being at a basketball game and on an intense graphic barrage of basketball shoe footprints, court lines, typography that flashes and pops on screen, and a 3-D basketball.

CREATIVE DIRECTOR / DESIGNER > Brian Diecks **PRODUCER** > Christia Crocker
ANIMATOR > Christopher O'Neil **CLIENT** > ESPN International > Ron Finkelstein,
director of creative services

INDEPENDENT FILM CHANNEL — NETWORK LAUNCH

For the launch of the Independent Film Channel, the firm focused on elements involved in making an independent film, such as cameras, film, light, and other pieces of equipment. The animation was divided into two segments: one black-and-white film segment and one graphic segment to house color-treated movie clips.

7·UP — "ARE U AN UN?" COMMERCIAL ENDTAG

Advertising agency Young and Rubicam approached the firm to design an endtag that would unify all 7-Up *Are U an Un?* soft drink commercials for debut during the Superbowl. Inspired by posters on buildings in SoHo, the firm scanned newspapers, acetate, metal, tissue, and other textures and organic elements into the computer. The elements combine and weave into an intriguing mixture of shapes, colors, and textures.

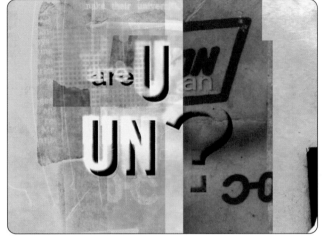

CREATIVE DIRECTOR / DESIGNER > Brian Diecks **PRODUCER >** Victoria Michael **ANIMATOR >** Christopher O'Neil
AGENCY > Young and Rubicam > Mootsy Elliot, producer; Rich Goldstein, art director

7-up is a registered trademark of Dr. Pepper/Seven Up, Inc.

THE FIRE OF FUEL

Ask employees of FUEL what it's like to work for the company, and invariably they will answer with a stream of adjectives rarely selected to describe work. "Fun," "awesome," and "laid back" are a few of the expressions used by employees of the four-year-old Santa Monica firm to describe its anticorporate culture.

"There is definitely a culture within FUEL that is youthful and energetic; it's a laid-back, looser environment to work in," says agency art director Vanessa Marzaroli. As an example, she points to the company's holiday gift one year to every employee: a snowboard.

It seems like an appropriate gift from agency founder Seth Epstein. Not too long ago, snowboards shook up the ski industry establishment with a radical new approach and attitude. Similarly, when Seth Epstein founded FUEL in the mid-1990s, the firm's Macintosh-only production process and guerilla spirit differed markedly from the broadcast design establishment. While many broadcast design firms had been using Macs for years, FUEL was one of the first to produce a majority of its work without involving a postproduction facility. FUEL's hands-on approach and use of desktop tools is now the model for startup broadcast design firms.

FUEL's youth and energy also lends the firm a strong competitive spirit. Perhaps because of its size, (the firm employs twenty-five full-time employees), the fact that the firm has only been in business five years, and the low average age of its employees, a younger-brother mentality pushes FUEL to want the competition to sit up and take notice. Sometimes this leads to zealous employee mischief.

"Our larger competitors don't understand us," explains Seth. "I'll get calls from them, yelling at me because their parking lot or building was tagged with FUEL stickers. If they don't understand the spirit of that, I'm not sure that they understand youth culture." According to Seth, the rise of FUEL's stature in the motion graphics industry has made more than a few competitors a bit nervous. "It would be one thing to be an up-and-comer without a good business structure. But we do great design, we are a great place to work, and we have a great business structure—and they know that."

Seth Epstein and his firm's employees clearly relish the spoiler position of the up-and-comer. Industry peers have formed another conclusion: FUEL has arrived.

M T V — "BIORHYTHMS"

MTV's *Biorhythms* describes key points in celebrities' lives with historical captions keyed to period music. FUEL applied the concept of "the web of life" as a visual biography that moves across a timeline. The show opening uses the heptagonal shape as a window for users to travel through periods of people's lives.

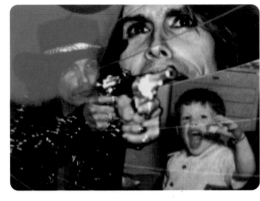

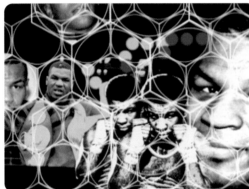

CREATIVE DIRECTOR > Seth Epstein **ART DIRECTOR >** Vanessa Marzaroli **DESIGNER >** David Vegezzi **ANI-MATORS >** Chris Kirk, Vanessa Marzaroli, Greg Taylor **PRODUCER >** Casey Steele

SUNCOM / AT&T — "IMAGE" / "GREAT DEAL" / "FINE PRINT"

SunCom/AT&T, a communications conglomerate, requested aggressive graphics that visually stress and enhance its package of digital service commercials. FUEL used these guidelines to convey a strong sense of energy in simple and clean visuals.

DIRECTOR / DESIGNER > Vanessa Marzaroli **EXECUTIVE PRODUCER >**
Matt Marquis **PRODUCER >** Rich Kaylor **ANIMATOR >** Ehren Addis

SLAMDANCE

FUEL's thirty-second trailer for the Slamdance Film Festival embodies the raw drive and energy of up-and-coming filmmakers.
The firm weaves an exciting montage from film footage of burning military-style storyboards and GI-style action figures
to dioramas with riveting animation and graphics.

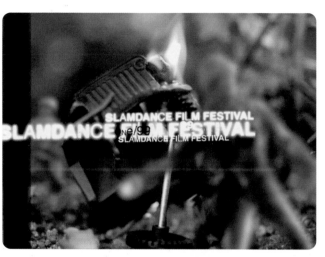

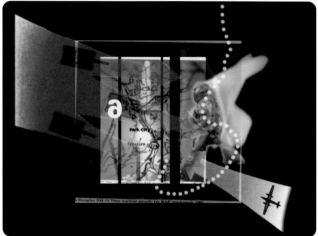

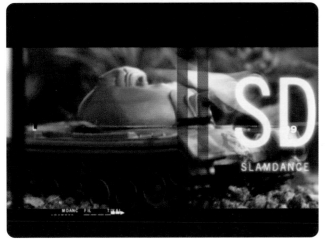

ART DIRECTOR / DESIGNER > Elizabeth Rovnick **ANIMATOR / PHOTOGRAPHER >** Brumby Bolyston **PRODUCER >** Casey Steele

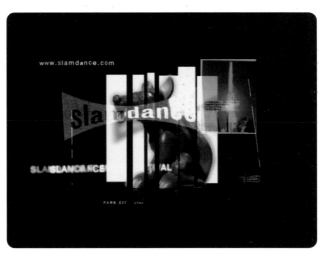

Graphics and animation enhance and simulate shots of athletes' live action and momentum.
The animation without live action uses images of the season and relevant sports.

ART DIRECTOR > Vanessa Marzaroli **DESIGNERS >** Jens Gelhaar, Vanessa Marzaroli **3-D ANIMATOR >** Ehren Addis **ANIMATORS >** Craig Tollifson, Lenie Ramos-Ortegaso, Brian Yarnell

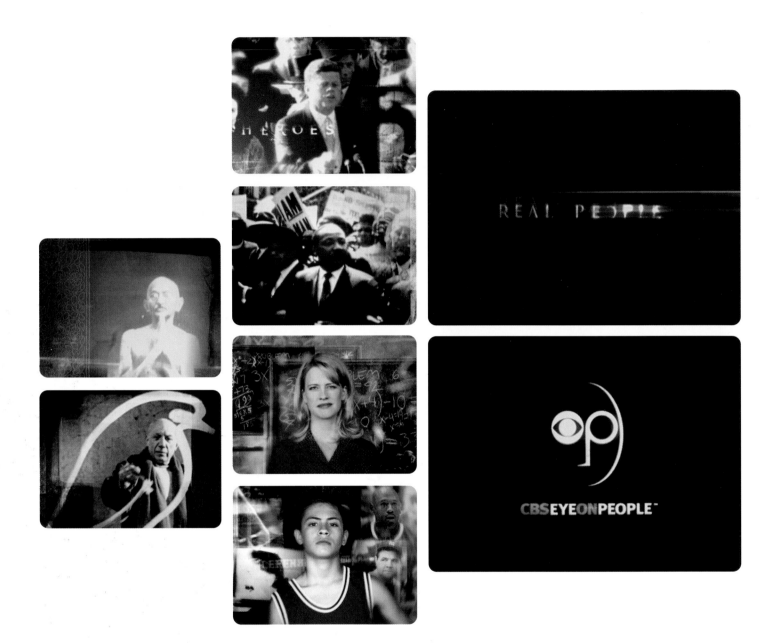

CBS — "EYE ON PEOPLE"

CBS's *Eye on People* assembled footage of heroes from the network's archive footage and FUEL's original live action that uses green screen. The graphics, designed by FUEL, and color palette were added in Flame. FUEL's goal was to show news integrated with the lives of everyday people.

DIRECTOR / CREATIVE DIRECTOR > Seth Epstein **PRODUCER >** Rich Kaylor
DIRECTOR OF PHOTOGRAPHY > Brian Dapp **FLAME ARTIST >** Simon Bruster

MTV — "THE CUT"

MTV's talent competition show, *The Cut*, presents individuals rising from the streets and making it to the top. The client requested a graphic opening to express the show's philosophy. Stylized, funky images with vibrant color set the stage for the performers.

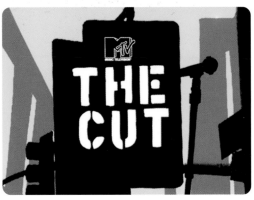

ART DIRECTOR > Vanessa Marzaroli **EXECUTIVE PRODUCER >** Matt Marquis **PRODUCER >** Jen Earle **DESIGNERS >** Bucky Fukumoto, David Vegezzi

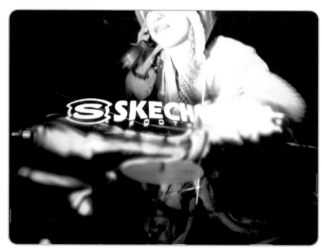

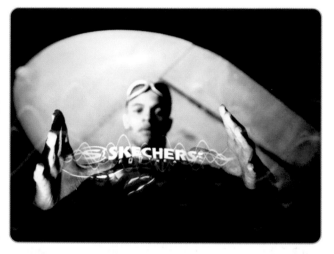

SKECHERS USA

Skechers, makers of trendy footwear, wanted one commercial for its day shoes and night shoes. FUEL shot two separate scenes, one of a thrashing rave party on a C-123 air transport plane, the other of youths in slow motion free-fall tumbling weightless in midair. Then FUEL intercut the two scenes to create a stimulating commercial that shows off differences between the day and night shoes.

DIRECTOR > Seth Epstein **PRODUCER >** Rich Taylor **DESIGNERS /**
ANIMATORS > Vanessa Marzaroli, Bucky Fukumoto **FLAME ARTIST >**
Cary Chadnick **EDITOR >** Fred Fouquet

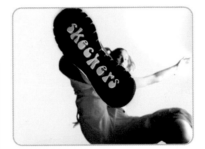

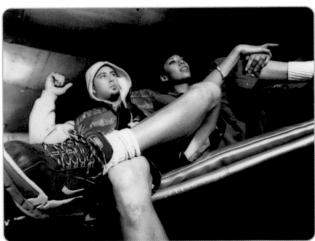

N B C — "GRAVITY GAMES"

Fuel created the graphics package for NBC's *Gravity Games*, an extreme sports competition. They conceived the idea of a mythological goddess of gravity, Gravity Girl. FUEL carries this futuristic goddess theme throughout in color, animation, and overall pacing. The colors are exotic, with a Moroccan and Egyptian feel. The animation style of the typography is quick cuts, while patterns are fluid and soft.

ART DIRECTORS / DESIGNERS > Elizabeth Rovnick, Vanessa Marzaroli
EXECUTIVE PRODUCER > Matt Marquis **PRODUCER >** Janet Arlotta

DOWN-UNDER DESIGN

A visionary company for the future of Japanese television, Global Japan was founded in September 1997 to create, package, and distribute programming for Japanese subscription television. Delivering niche networks, Global Japan is dedicated to the passions of audiences who, in the past, have been ignored by cable, satellite, and terrestrial programming providers.

Global Japan's first two channel entries deliver from a strategy that focuses on entertainment genres that appeal to men and women aged eighteen through thirty-four. SheTV is designed to appeal to the interests of young Japanese women who clamor for a channel to call their own. SheTV is the only women's network in Japan. SF taps into the wildly popular following of fiction/cult/mystery/horror genres with both Japanese- and Western-originated programming.

With companies and people being electronically linked around the world, it was a relatively simple process for New York-based Global Japan to commission channel-imagery design in Sydney, Australia. The channel-imagery packages then were broadcast on SheTV and SF in Japan. This unique process not only has had economic benefits. It also has gone on to win several GOLD BDA and PROMAX awards in Asia and the United States. According to Sydney-based Creative Director Diana Costantini, digital media helped considerably to streamline the approval processes between the New York network and the Sydney-based design team.

GLOBAL
JAPAN

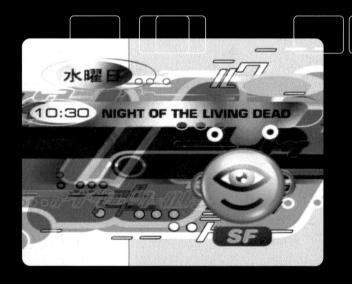

水曜日
10:30 NIGHT OF THE LIVING DEAD
SF

"The world really is getting smaller. With work in progress, files being put on-line, and quick-time animations being sent to New York for approval, it is an easy and productive way to generate design," says Diana.

Global Japan is a new and progressive company, willing to try new and different international liaisons. The result of this open-mindedness is evident in its success in building its first two brands.

S F — ON-AIR IDENTITY

SF is a science fiction network that features fiction/cult/mystery/horror genres with programming that originates from Japan and the West. The identity features a fun, Cyclops alien that is presented in surprising and always entertaining situations and environments. The logo has the flexibility to be animated in various two-dimensional and three-dimensional styles, allowing the designers to "bring the logo to life" with personality and style.

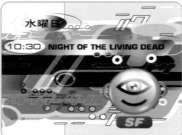

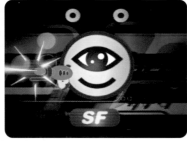

CREATIVE DIRECTOR > Diana Costantini, T A C T I C Creative Services
DESIGNER > Dana Rayson, Garner Maclennan Design ANIMATOR > Robert Malherbe

SHETV—ON-AIR IDENTITY

For SheTV, Japan's only channel specifically targeted toward young women, the designers created a fresh, young, sophisticated on-air look with broad appeal. The SheTV identities are eclectic compositions of objects, textures, and live-action photography of Japanese women.

DESIGNER > Dana Rayson, Garner Maclennan Design
CREATIVE DIRECTOR > Diana Costantini, T A C T I C Creative Services

LAUNCHING CHANNELS

"We design channels." Hatmaker's confident, succinct marketing statement makes it sound so simple. According to Beth Kilcup, president of Hatmaker, the phrase neatly summarizes what distinguishes the firm from competitors. "That phrase is our differentiator. Not a lot of firms can say that they have the thinking and strategic capabilities to help a company brand, position, and then launch an entire network or channel." Few firms can match Hatmaker's or founder Tom Corey's history of launching channels.

Tom started his career in broadcast identity as part of the creative team that so triumphantly launched MTV and Nickelodeon in the early 1980s. He also produced early print work for Showtime and the Movie Channel. From the success of these projects, Tom's clients grew to entrust him with the full scope of their brand, from naming to on-air identity.

HATMAKER

Today, Hatmaker continues to justify that level of confidence by ensuring a filterless relationship between the client and the designer entrusted with a network's most valuable possession: its brand identity. Technical Director Austin Wallender notes, "At Hatmaker, the designer is the primary client contact. They are the project director and creative lead responsible for every aspect of the project, from the budget to the overall look. This person stays with the client from print through broadcast; there is no middleman to water down the process."

Hatmaker Creative Director Chris Goveia, who has spent four years leading the Cinemax account for Hatmaker, credits much success in that relationship to its directness. "Nobody knows the product better than the client, and the more you get involved with them, the better you'll be at solving the problem." Hatmaker's track record is proof that if you respect and satisfy the needs of the client, you'll satisfy the audience. It's that simple.

CINEMAX — RELAUNCH

When the cable channel Cinemax was relaunched as "the movie channel for the movie fan," the company turned to Hatmaker, which created a spirited on-air look influenced by pop art. The firm used highly stylized photographic images of Cinemax movie fans and featured the Cinemax dot as the most important graphic element. Hatmaker superimposed dot patterns and halftones over the imagery. Bright, energetic colors and images reflect the emotions and excitement of moviegoing fans.

CREATIVE DIRECTOR / DESIGNER > Christian Goveia **PROJECT MANAGER / PRODUCER >** Mark D'Oliveira **DESIGNER >** Tom Nielson **IN-HOUSE ANIMATOR >** Austin Wallender **POSTPRODUCTION FACILITY >** Pisces Productions **FLAME EDITOR >** Dave Waller **OFFLINE / ONLINE EDITOR >** Rob Thompson **STILL PHOTOGRAPHY >** Christopher Harting **MUSIC >** Brother Cleve **CLIENT >** Cinemax > Mark Davidson, director of creative services; Andy Verderame, manager of creative services

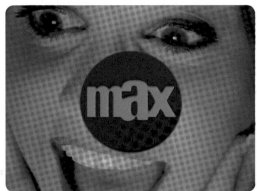

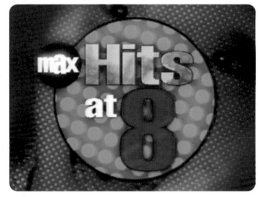

CINEMAX—MULTIPLEX CHANNELS

After Cinemax launched the new identity, Hatmaker created identities for three new multiplex channels—Moremax, Actionmax, and Thrillermax—as extensions of the Cinemax brand. Using distinct color palettes and genre-specific imagery as key ingredients, Hatmaker created a cohesive family of brands whose members each convey an individual on-air look that maintains a strong visual connection to Cinemax.

MOREMAX

Because Moremax features more of the same popular movies found on the main Cinemax channel, the identity relates to the parent brand. Hatmaker used the same color palette in a fresh design for the new brand.

CREATIVE DIRECTOR / DESIGNER > Christian Goveia PROJECT MANAGER / PRODUCER > Mark D'Oliveira DESIGNERS > Haig Bedrossian, Daniel Luzier IN-HOUSE ANIMATOR > Austin Wallender POSTPRODUCTION FACILITY > Pisces Productions FLAME EDITOR > Dave Waller OFFLINE / ONLINE EDITOR > Rob Thompson LIVE-ACTION PHOTOGRAPHY > Mark Werthner, Scott Greig STILL PHOTOGRAPHY > Christopher Harting MUSIC > Brother Cleve CLIENT > Cinemax > Mark Davidson, director of creative services; Andy Verderame, manager of creative services

THRILLERMAX

Thrillermax targets fans of mystery and suspense thrillers, so Hatmaker turned to noir imagery of dark alleys, smoking guns, and chalk lines, plus thriller-movie clips and suspenseful music. Images of shattering glass either expose the Thrillermax logo or serve as a visual transition. The overall dark and creepy aura of Thrillermax sets the mood for mystery and suspense.

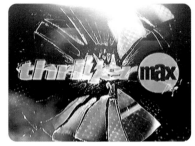

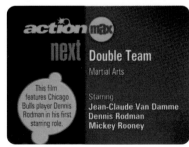

ACTIONMAX

High-energy, high-intensity movie channel Actionmax aims at the action-movie junkie. Hatmaker distorted elements from action films and paired them with iconic images such as guns, bombs, explosions, and fire to create miniature movielike clips. For effect, the designers formed transitions with visuals of action, like explosions and sparks. The color palette of intense reds, yellows, and black, associated with specific imagery and powerful music, speaks to action-movie fans through tone and attitude.

13TH STREET—LAUNCH

When Universal Studios Television Networks decided to launch a 24-hour action/suspense channel for a European audience, it challenged Hatmaker to develop, design, and produce its on-air personality, including name development, branding, and positioning. To present a channel that translated internationally while maintaining visual identity, Hatmaker created a street-sign logo that can display any language. The result—a package that travels across borders to markets such as France, Germany, and Spain.

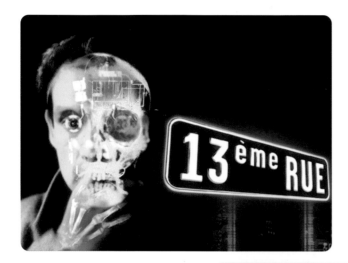

CREATIVE DIRECTOR > Tom Corey **PROJECT DIRECTORS >** Tom Corey, Haig Bedrossian **PROJECT MANAGERS >**
Marianna Gracey, Elz Bentley **PRODUCERS >** Marianna Gracey, Susan Archer **DESIGNERS >** Haig Bedrossian, John Duffy
DIRECTOR / CAMERA > Scott Grieg **EDITORS >** Austin Wallender, Haig Bedrossian, Shondra Merril **ANIMATORS >**
Austin Wallender, Haig Bedrossian **ILLUSTRATOR >** Ted Smykal **MUSIC >** Patterson Walz Fox **CLIENT >** Universal Studios
Television > Trace Harris, Marsha Armstrong

13TH STREET — "EVIDENCE" IDS

Hatmaker created a series of "Evidence" IDs in which viewers discover the 13th Street logo as a piece of evidence from a crime scene. These scenarios include a photographer who enlarges a photograph to reveal the 13th Street logo, luggage that reveals the logo when X-rayed by security at an airport, and a detective who discovers the logo while dusting for fingerprints.

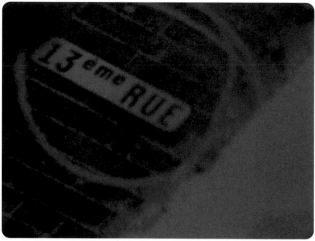

The "Evidence" and "Story Line" IDs form a dramatic,
stylized, cinematic, and international on-air look.

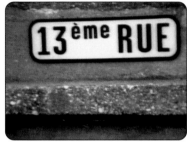

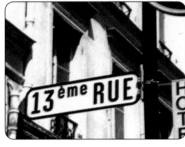

13TH STREET— "STORY LINE" IDS

This comprehensive identity package included much live-action production. The firm transformed a series
of highly stylized filmed shots into a flexible story line. The shots were designed as interchangeable components
of almost endless variations.

CREATIVE DIRECTOR > Tom Corey **PROJECT DIRECTOR >** Tom Corey **PROJECT MANAGERS >** Marianna Gracey,
Elz Bentley **PRODUCERS >** Marianna Gracey, Susan Archer **DESIGNER >** Haig Bedrossian **DIRECTOR / CAMERA >** Scott Grieg
EDITORS > Austin Wallender, Haig Bedrossian, Shondra Merril **MUSIC >** Patterson Walz Fox **CLIENT >** Universal Studios Television >
Trace Harris, Marsha Armstrong

WITH KNOBS ON

"A magic marker doesn't touch a layout and an Apple Mac doesn't get booted up until, in collaboration with our client, we have arrived at a positioning, formulated a marketing strategy, and agreed on a creative brief. What we have come to understand is that marketing is not just a good idea; it's a matter of survival. These days, a television channel is just another product on an increasingly overcrowded supermarket shelf. It is a brand."

—Martin Lambie-Nairn, from his book, *Brand Identity for Television "With Knobs On"*

Martin Lambie-Nairn, founder of Lambie-Nairn in 1976, is one of the world's foremost designers and
art directors working in television identity. He has produced groundbreaking work in British television, such as the Channel 4
identity and the redesign of the BBC TWO identity. The company specializes in developing corporate identities, working from
a strategic understanding of the client's objectives through the creation and implementation of all the appropriate creative
expressions of that identity.

The firm works closely with television companies to enable them to
maximize their image and to position themselves more effectively in a
competitive marketplace. Its global portfolio of clients ranges from
BBC ONE and BBC TWO to the Disney Channel and TF1.

So influential and respected is the firm in the television industry that the courses it offers
on the theory and practice of television marketing and branding have been attended by
delegates from TV stations from all over the world.

Martin's unique qualities, which are reflected throughout the company culture, are a total
belief in strategy driving design, a ruthless pursuit of ideas before aesthetics, and a
rigorous integrity in client relationships and business practice.

BBC ONE—REPOSITIONING

Lambie-Nairn's strategy to reposition BBC ONE was to move the channel away from its traditional image toward one of a "forward-looking, universally popular, self-confident, diverse, solid" entity that conveys "a feeling of oneness and unity." The balloon concept articulates all of these values in larger-than-life imagery. It celebrates the brand value to the nation by communicating the message that "BBC ONE brings the whole world to every corner of the United Kingdom."

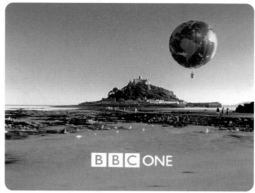

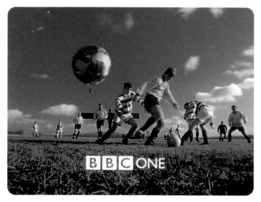

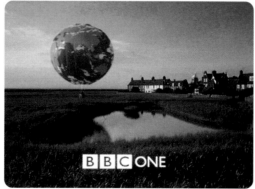

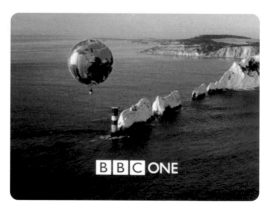

CREATIVE DIRECTOR > Martin Lambie-Nairn DIRECTOR > Jason Keeley DESIGNER > Jason Keeley PRO-
DUCER > Linda Farley CGI > Phil Hurrel, SVC EDITOR > Tom McKerrow, SVC MUSIC > Phil Sawyer, Amber

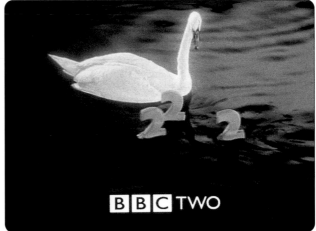

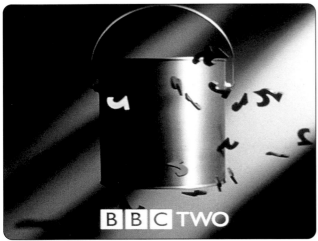

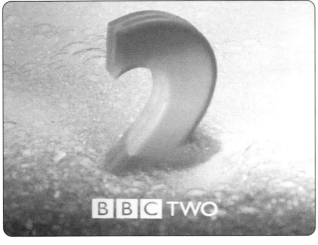

BBC TWO — IDENTITY REDESIGN

Lambie-Nairn was responsible for redesigning the identity for BBC TWO. The firm gave the "two" itself a tangible personality to reflect the channel's programming. Irrepressible, fun, and quirky, the live-action sequences were exceptionally effective in helping to counter the channel's previously staid image. New two's are continually added to reflect the channel's personality.

CREATIVE DIRECTOR > Martin Lambie-Nairn **DIRECTOR** > Rob Kelly **DESIGNER** > Rob Kelly **PRODUCER** > Mark Sherwood
LIGHTING CAMERAMAN > Karl Watkins **POSTPRODUCTION** > Framestore **MUSIC** > Tony and Gaynor, Logorhythm

CHANNEL 4 — CORPORATE IDENTITY

Channel 4 Television was the first UK channel to offer a complementary, instead of a competitive, broadcasting service, an eclectic mix of programming designed to appeal to a broad range of interests. Channel 4's corporate identity has profoundly influenced television style in the United Kingdom and beyond.

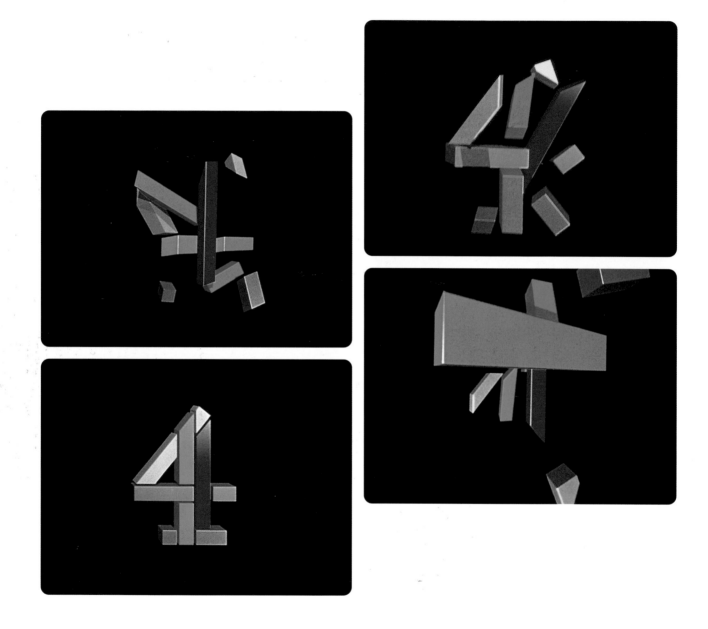

CREATIVE DIRECTOR > Martin Lambie-Nairn COMPUTER ANIMATION > Tony Pritchett, Bo Gehring Aviation and Information-al, Inc. (Ill.) MUSIC > David Dundas ACCOUNT DIRECTOR > Ian St. John PRODUCER > Sarah Davies

GLOBAL TELEVISION — NETWORK BRAND IDENTITY

Canada's CanWest Global Communications owned and operated six individually branded regional television stations across Canada. The new Lambie-Nairn work unified all six stations with a single brand identity. The on-screen identity develops around visual puns on the idea of a globe, puns that only suggest the globe's presence.

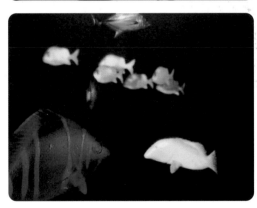

CREATIVE DIRECTOR > Brian Eley **DIRECTOR >** David Chaudior **PRODUCER >** Alison Fensom
MUSIC COMPOSITION > Joe Glassman, Hum
COMPUTER GRAPHICS > Phil Hurrell, Howard Bell, SVC
FLAME / ONLINE EDIT > Pete Smith, SVC

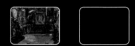

A STRATEGIC POINT OF VIEW

One attractive aspect of broadcast design is the ability of practicing firms to build a substantial list of clients within one industry. Such has been the fortune of New York-based Lee Hunt Associates (LHA), which has been involved in the development and branding of more TV networks than any other firm in the United States. Lee Hunt, president of LHA, credits the group's successes to its focus on creative strategy and implementation:

"Primarily what sets us apart is the strategic point of view, looking at and defining and differentiating clients from their competitors. First we look at consumers. What do they want? What do they need? What are they missing? Then we look at the competition, where the strengths, weaknesses, and opportunities are. Finally, we look at the assets of our clients and determine what they have to offer. Where those three overlap is the point of strategic leverage where we begin all of our communications."

LHA Creative Director Bob English points to creative versatility as another aspect of the firm's strength."We're not tied to any particular technique or style. We don't believe everything should be computer graphics or everything should be live action or 3-D graphics. It comes down to what is really appropriate for the job. We're all about ideas and concepts, not about technique. We have to be chameleons and do things that are appropriate for the client and the project."

According to Lee, if the homework is done well at the strategic and creative stages of the project, the need for postcreative focus-group tests is lessened. "Some clients really believe in it, and there are others for whom it's all about gut." He points out two well-known industry success stories, NBC's "Must See TV" and MTV's changing, morphing logo. Those concepts bombed in testing, but the networks stuck with their instincts and the concepts eventually achieved major success. "Research is always good for raising red flags, but at the end of the day, research can only tell you where people have been and not where they are going."

INTRO TELEVISION—RELAUNCH

Intro Television is a channel that provides samples of programming from the diverse offerings of cable television. LHA's funhouse series of animated IDs for Intro Television switches viewers between the sampled channels in an entertaining way. The challenge was to create a strong visual transition between the networks while maintaining the Intro Television identity. The spots resulted from the creative collaboration of Intro Television, LHA, and Bad Clams, a Los Angeles-based animation company.

CREATIVE DIRECTOR > Linda Ong **EXECUTIVE PRODUCER >** Virginia Kuppek **COPYWRITERS >** Lee Hunt, David Seeley
DIRECTOR OF CREATIVE SERVICES > Mike Watson, Intro **DIRECTOR / ART DIRECTOR >** Mark Osborne, Bad Clams, Los Angeles
ASSISTANT ART DIRECTOR > Tim Ellis

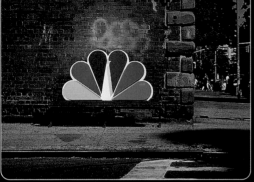

NBC—**FALL SEASON CAMPAIGN**

LHA based NBC's entire "Must See TV" fall 1998 creative campaign on the network's six colors—
blue, green, red, purple, yellow, and orange. The firm explored the brand essence of the NBC
peacock logo by bringing the six colors to life in a variety of ways.

DESIGNER / DIRECTOR > Juan Delcán **SUPERVISING PRODUCER >** Robert Buganza **EXECUTIVE PRODUCER >** Jill Lindeman
PRODUCTION COORDINATOR > Carolina Cajiao **DIRECTOR OF PHOTOGRAPHY (LA) >** Christopher Baffa, Datner and Associates **DIRECTOR OF**
PHOTOGRAPHY (NY) > Frank Prinzi, Gersh **SPECIAL EFFECTS SHOOT >** Stargate Films, Burbank, CA **TECHNICAL DIRECTOR >** Dan Schmitt,
Stargate Films **TELECINE (4:2:2) >** Rob Sciarratta, Hollywood Digital **PRODUCTION 3-D COMPUTER ANIMATION >** Computer Cafe, Santa Monica, CA;
SPECIAL EFFECTS SUPERVISOR / LEAD FLAME EDITOR > Brian Buongiorno, 525 Post Production, Hollywood, CA **POSTPRODUCER >** Jenny Bright
OFFLINE EDITOR > Steve Rees **TELECINE (4:4:4) >** Paul Bronkar, Mike Cosola, Corey Olson, Clark Muller **FLAME ARTISTS >** Geoff McAuliffe, Scott
McNeil, Patrick Poulatian, Steve Meyer **CLIENT >** NBC > John Miller, executive vice president of advertising and promotion and event programming; Vince Manze, senior vice
president of advertising and promotion; Bob Holmes, executive in charge of production, special projects and events; Brad Gensurowsky, creative director, NBC Magic Room; Katie
Scott, postproduction supervisor, NBC Magic Room

COURT TV—REDESIGN

LHA was commissioned to redesign and create a comprehensive on-air package for Court TV. Anchored by a striking new logo, the redesign maintains the network's established credibility while reinforcing its expanded focus on crime and justice programming. Courtroom and judicial images were used for daytime and crime-scene photographs for primetime.

CREATIVE DIRECTOR > Bob English EXECUTIVE DIRECTOR CREATIVE > Jill Lindeman EXECUTIVE DIRECTOR OF PRODUCTION >
Jane Friesen EXECUTIVE PRODUCER > Maribeth Phillips COPYWRITER > Karl Cluck DESIGNER > Kylie Matulick LINE PRODUCER > Anne Mullen
AFTER EFFECTS ARTISTS > Kylie Matulick, Jojoe Spaid FLAME ARTIST > Kieran Walsh, Manhattan Transfer MUSIC PACKAGE > Video Helper
PHOTOGRAPHER > Chris Amaral CLIENT > Court TV > Dan Levinson, executive vice president of marketing; Art Bell, executive vice president of strategic planning;
Sheilagh McGee, senior vice president of programming; Rudy Gaskins, vic

More emotion
in one week

Lifetime
Premiere week
Starts August 17th

Don't miss a moment

than the first month
of a relationship.

Girls mature faster.

More emotion in one week
than that vacation you took
with his parents.

Lifetime
Premiere week
Starts August 17th

Don't miss a moment

LIFETIME — FALL SEASON CAMPAIGN

LHA created an innovative brand campaign to support one of the Lifetime cable channel's biggest assets: programming that presents female perspectives and sensibilities. "We were able to exemplify the key points of Lifetime's overall image," says Lee Hunt. "Lifetime's strength is serving as a voice for women and empowering them with TV they can't get elsewhere."

DIRECTOR > Bob Mowen **CREATIVE DIRECTORS** > Lee Hunt, Linda Ong **ACCOUNT EXECUTIVE** > Kate Cestar
EXECUTIVE PRODUCER > Lynn Sadofsky **COPYWRITERS** > Karl Cluck, Jenny Noble, Ann Lemon **DIRECTOR OF
PHOTOGRAPHY** > Dan Stoloff **MUSIC** > Elias Associates **EDITOR** > Bryan Monzella **CLIENT** > Lifetime > Peter Risafi,
vice president and creative director

ANIMATED ELEGANCE

While a majority of on-air design comes from specialized broadcast design firms and in-house departments, a growing . number of print-oriented design boutiques have thrown their hats into the arena of design for television and have made their presence known. For an example, look no further than Margo Chase Design. Over the past eleven years, the firm's landmark logo designs for music icons Madonna, The Artist Formerly Known as Prince, and Bonnie Raitt, and the firm's movie-poster designs, including Francis Ford Coppola's *Dracula*, have gained it international recognition. The firm's earlier reputation in the entertainment business was based on Margo's elegantly stylized, Gothic-inspired identity and promotional print work and packaging. When the chance came to expand her talents into broadcast animation work on a project for ESPN, Margo jumped at the opportunity:

"ESPN called and asked us to design logos for boxing and billiards, and the idea was that somebody
else would animate it," she recalls. "I said, 'We would like to animate it ourselves.' At that point,
we had been experimenting with motion graphics and I had been taking classes, but we didn't have
a reel. But I convinced them that we would do a great job and promised that if they weren't satisfied,
they wouldn't have to pay for it." ESPN agreed, and the project turned out to be a great success
for all involved, earning gold and silver awards at the 1997 Promax/BDA conference.

ESPN got outstanding show openers, and Margo got a boot-camp production experience by working with a film crew and
hands-on with Media 100 nonlinear editing and After Effects animation software. She says that she now views the style
of animation in the ESPN projects as "primitive" compared with the firm's current work. But she notes that it was appropriate
for the concept, which was based on old-time boxing posters.

The firm's experience in motion graphics has carried to the Internet, where it is designing and
producing Web sites and animation for entertainment clients. Margo emphasizes that the diversity
of the work is creatively important to the firm. When it comes down to choosing her favorite medium,
however, she is still a print designer at heart. "What I like about designing print or packaging is
that when the job is finished there is something physical to show for it—it's timeless. With the
broadcast work, once it's been seen, it's already old."

ESPN BILLIARDS—

SHOW OPEN

The show opener for *ESPN Billiards* combines bold typography composited on graphic abstracted pool-table footage. The typography breaks and scatters in all directions, just as balls do at the beginning of a game of pool.

CREATIVE DIRECTOR > Noubar Stone
DESIGNER > Margo Chase

ESPN BOXING — SHOW OPEN

For a show opener for *ESPN Boxing*, Margo created a look reminiscent of old-time boxing posters, with woodcut typographic headlines that recall the history of the sport. The graphics were superimposed on blurry action footage of boxers in a ring.

CREATIVE DIRECTOR > Noubar Stone **DESIGNER >** Margo Chase **PRODUC-TION COMPANY >** John Colby, FUEL Audio

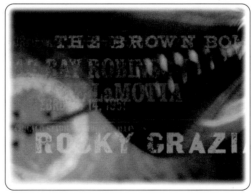

CREATIVE DIRECTOR > Margo Chase **DESIGNER** > Margo Chase
AUDIO > Rhino Records > Del Close, John Brent

RHINO RECORDS—
BASIC HIP, PROMOTIONAL VIDEO

For this promotion for Rhino Records, simple typography underscores the humorous audio, in which a straightlaced narrator attempts to define the concept *hip* through an interview with a beatnik. The typography graphics illustrate the audio through a contrast of *hip* and straight typography and simple and complex compositions.

BILLBOARD LIVE — TELEVISION IDENTITY

For the on-air identity and menu system for a broadcast version of *Billboard* magazine, Margo Chase Design created an atmosphere that is raw, textural, youthful, and contemporary.

CREATIVE DIRECTOR > Adam Bleibtreu
DESIGN DIRECTOR > Margo Chase
DESIGNERS > Brian Hunt, Andreas Heck, Dave McClain

ALPHABET — SELF-PROMOTION

This self-promotion piece serves as a showcase for the firm's exceptional artistry when creating original letterforms. The simplicity of a child's voice reciting the alphabet is playfully illustrated with unique and sophisticated individual letterform designs.

CREATIVE DIRECTOR > David Shih
ART DIRECTOR > Margo Chase
AUDIO > Hum

AMERICAN HEALTH NETWORK—

TELEVISION IDENTITY

Cable Health Network *AHN* needed a facelift for its planned expansion into new markets. The graphic solution combines three-dimensional transparent typography, bold colors, and stylized backgrounds. These features communicate the forward-thinking high-tech nature of the network with an element of fun to which families could relate.

CREATIVE DIRECTORS > Margo Chase, Christopher Willoughby **DESIGNER >** Jonathan Sample

ROCK EN ESPAÑOL

MTV Latin America, a unit of MTV Networks Inc., is a twenty-four-hour Spanish-language cable television network that offers music programming for young people in Latin American and U.S. Hispanic markets. Since it went on the air in 1993 with its first video, *We are South American Rockers* by Los Prisioneros of Chile, MTV has been a powerful cultural force for the baby-boomer generation of young Latin Americans and U.S. Hispanics, dubbed by some as "Generation Ñ," the Latin equivalent of the so-called "Generation X."

MTV Latin America speaks directly to the interests and lifestyles of Latin youth culture in their own language. Programming features a mix of Latin and international music videos, local and regional productions, music and entertainment news, artist interviews, concert coverage, and unique contests and specials pr

MTV LA's on-air graphics, led by creative director Cristian Jofre, have been consistently smart and edgy. They work across the varied and unique regions and countries in which the network is broadcast. The effectiveness of MTV LA's on-air identity has helped the network reach across cultures and has contributed greatly to the network's status as the number-one cable network in Spanish-speaking Latin America.

While most of the network's graphics are produced in-house with his staff of seven, Cristian prefers to work directly with freelance artists and animators, as opposed to studios or firms. This approach not only is more cost-effective, but also it generally results in more creative, edgier, and more experimental solutions. "We produce around 300 spots a year, we run twenty-four hours a day, and it needs to stay fresh—something runs for two weeks, and then we pull it off. I think the people in Latin America really appreciate that. There is no other station where they can see this type of work."

Ironically, many times Cristian and his animators have turned to antiquated cameras, old computers, or outdated production techniques in order to find a fresh look. "We make mistakes all the time, which is good, because sometimes those mistakes look very nice."

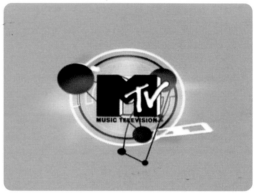

DESIGNER > Fernando Lazari
CREATIVE DIRECTOR > Cristian Jofre

M T V — DELIRIO

This identity spot combines three-dimensional typography, two-dimensional graphics, and computer animated wire frames into a single, rotating composition on a yellow field. This techno-driven piece only ran in alternative music-orientated shows.

MTV—LOS 5 MÁS PEDIDOS

As a generic bumper to provide the time, Web address, and the five most requested videos, each person or character in this surreal circus freak show represents a number in the countdown.

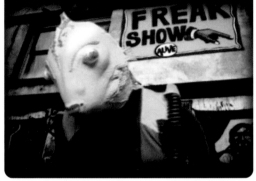

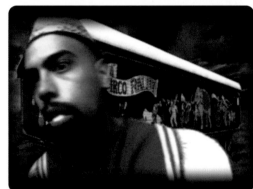

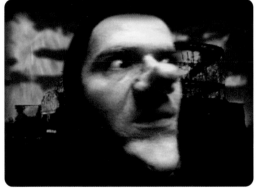

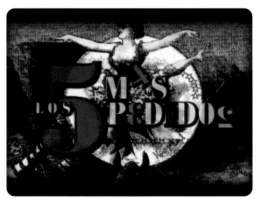

DESIGNER > Alejandro Abramovich
CREATIVE DIRECTOR > Cristian Jofre

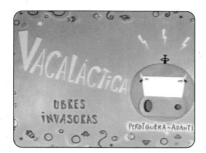

MTV — VACALACTICA

Vacalactica is a twelve-episode animated adventure of a space-traveling cow.
It was created by animating dimensional paper cutouts and hand-rendered illustrations.

ANIMATOR > Dario Y Barbara Danti
CREATIVE DIRECTOR > Cristián J. Fofré

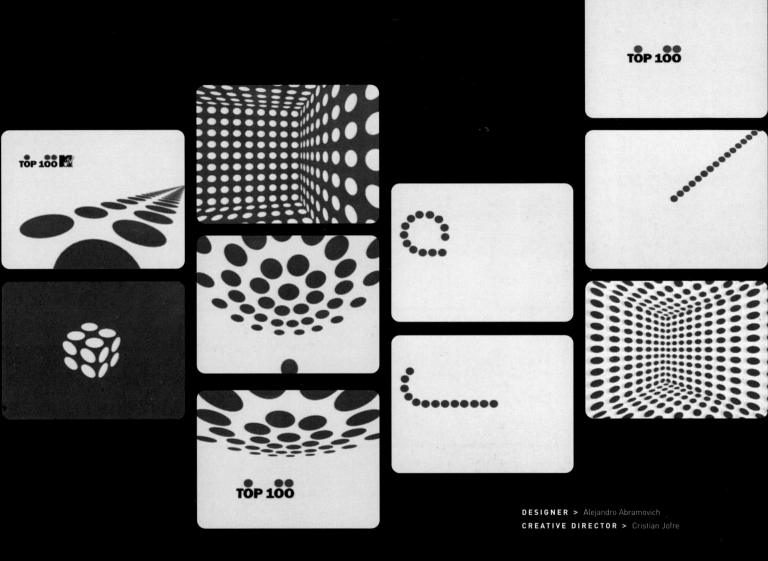

DESIGNER > Alejandro Abramovich
CREATIVE DIRECTOR > Cristian Jofre

M T V — **TOP 100**

The show-opening for Top 100, a countdown of the top music videos of the week, was created
entirely out of red spots and typography. The red spots are distorted on planes in 3-D software to
create the illusion of depth and distance in order to project a sleek and modern environment.

MTV—NOTICIAS OPEN

This news-brief opening creates a high-tech and futuristic identity from imagery that surrounds a stylized news satellite, beaming the news from MTV headquarters to the world below. The graphics lend the news show an "up-to-the-minute" persona.

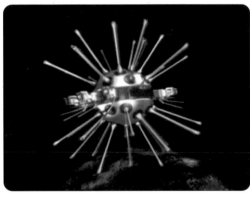

3-D DESIGNER > Jose Wolf
DESIGNER > Ricardo deMontriul

MTV — MORGUE IDENTITY SPOT

This darkly humorous identity spot uses comic-book-style animation to show an autopsy being performed on a cadaver. The visual combination of a grotesque organic object being removed from the cadaver and laid into an *M* shaped surgeon's pan forms the familiar MTV logo.

ANIMATOR > Ricardo deMontriul **CREATIVE DIRECTOR >** Cristian Jofre

MTV — SUPER ROCK

This promotion for a hard-rock show has a raw, underground feel created with still cameras and frame-by-frame animation combined with graphics. It features a man with a massive rock-head who watches television on the street.

DESIGNER > Alejandro Abramovich **CRE-ATIVE DIRECTOR >** Cristian Jofre

CREATING VALUE

Variety magazine has described Billy Pittard and Ed Sullivan as the Lennon and McCartney of broadcast design. Just as it is hard to turn on a radio and not find the songs or influence of the Beatles, it is difficult to watch television and not encounter the work or influence of Pittard and Sullivan. Their thirteen-year-old firm, Pittard Sullivan, has produced more broadcast designs and has won more awards than any other firm in the design industry. The founders are credited with pioneering an on-air look that integrates typography and live action as aesthetically breathtaking as it is commercially effective, a look that now has been co-opted by much of the broadcast design industry.

The company's philosophy of strategically implemented and marketing-driven broadcast design proved no less influential than its original approach to visual solutions. Before Pittard Sullivan, most broadcast design occurred in-house or at a posthouse. Though earlier high-end graphics systems operators may have been graphically savvy, they were not trained in the areas of marketing and strategy. Pittard Sullivan helped clients to step outside of themselves, think strategically, and fully exploit the potential of network graphics to solve problems. "Our role is to create value for clients, driven by the unique qualities of their company. From this comes good work." explains Billy Pittard.

According to Ed Sullivan, his firm's blueprint, from the beginning, has been to postition the company as king of the hill in design for entertainment and media properties and to build services and resources as the category demands."We've had to be a little avant-garde to stay ahead."

Pittard Sullivan's size and scale results from building creative teams by which to develop long-term initiatives for clients. Teams may have as many as twenty people simultaneously working on a single phase of a client's project.

PITTARD SULLIVAN

Despite its size, the company prevents the atmosphere from becoming too corporate or employees from becoming too isolated, strengthening its art-school atmosphere partly by a program unofficially referred to as "Pittard Sullivan University." Once a week, employees from the creative departments get together for sessions that can be inspirational, creative, or technical. These sessions can take the form of lectures, field trips, or simply getting together to watch a great movie.

It is this type of nurturing environment that Billy Pittard points to as the inspirational core of his firm. "We only hire great people who want to learn, grow, and work with other talented people to do great work. We provide our employees with an atmosphere in which they can really blossom."

C T V — NETWORK RELAUNCH

Canada's premier network, CTV, wanted to reinvent its on-air look by associating a sub-brand genre with each shape and color in its logo: a red circle for sports, a blue square for news, a green triangle for entertainment. Each tease focuses on its own shape and color; distinctive Canadian landscapes form a secondary background element.

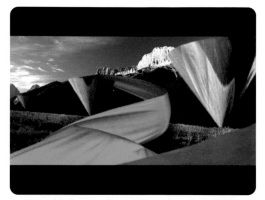

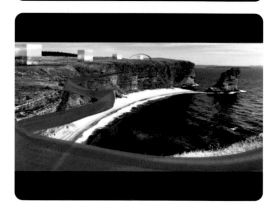

The shapes are huge monumental forms that spread over and encompass the land. The logo colors are represented with vibrant tones of fabric that emanate from a distant human figure, covering miles of landscape. Viewers' explorations of the environments build to an epic panoramic view accompanied by ethereal and melodic music. In the last scene of each tease, the launch date fades up to visibility.

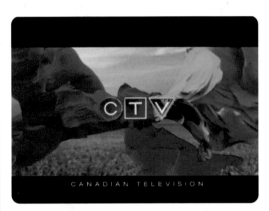

DESIGNERS > Paul Newman, Dan Appel CREATIVE DIRECTOR > Paul Newman PRODUCER > Wendy Gardner
ACCOUNT MANAGER > Alan Schulman EXECUTIVE PRODUCER > Noreen O'Donnell LIVE-ACTION PRODUCER >
Wendy Gardner PRODUCTION MANAGER > Treehouse North POSTPRODUCTION COORDINATOR >
Beth Vogt LIVE-ACTION DIRECTOR > Dan Appel STUDIO DIRECTOR > Paul Newman
LIVE-ACTION DIRECTOR OF PHOTOGRAPHY > Russell Fine STUDIO DIRECTOR OF PHOTOGRAPHY >
Andrew Turman 3-D ANIMATOR > Mario Marengo, AXYZ INFERNO ARTISTS >
Dave Giles, Steve Zourntos, AXYZ AVID EDITOR > Granty Pye, Third Floor

ABC — 1998 FALL IMAGE CAMPAIGN

With a clean and simple look that reflects the sophistication of the network and the shows that it offers, the 1998 fall image campaign was designed to position ABC as clever, irreverent, and honest. The package consists of talent IDs, graphic IDs, show transitions, commercial bumpers, lineups, promotional packaging, and campaign teases. New signature music accompanies Pittard Sullivan's designs for a distinctive ABC identity.

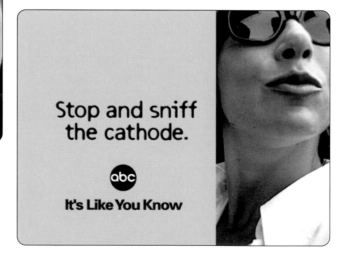

abc

We Love TV.

The Drew Carey Show

abc

Next

Next

abc The Hughley's

Next

abc Home Improvement

DESIGNERS > Dan Pappalardo, Pam Haskin **CREATIVE DIRECTOR >** Dale Everett **PRODUCER >**
Todd Arnson **ACCOUNT MANAGER >** Marty Wall **GRAPHICS COORDINATOR >** Jason Ferrell
STILL PHOTOGRAPHER > Norman Jean Roy **LIVE-ACTION PRODUCER >** Susan Harris
PRODUCTION MANAGER > Lisa Bansbach **DIRECTORS >** Dan Pappalardo, Pam Haskin, Dale Everett
HENRY ARTIST > Mitch Cardwell **EDITOR >** John Kyd, CCI **PRODUCTION ART DIRECTOR >**
Robert Shepps **IMC / VIDEO CAPTURE >** Rusty Colby, CCI **DESIGN ASSISTANT >** Kevin Sullivan
MUSIC COMPOSERS > David Resnick, Jim Goodwin, Mad Bus

THE WONDERFUL WORLD OF DISNEY— SHOW OPENER

Pittard Sullivan was asked to create the show opener for *The Wonderful World of Disney*. Combining live action (more than forty hungry Dalmatian puppies), 3-D graphics (the castle itself), rotoscope clips from classic films (*The Lion King* and *Fantasia*), and original Disney cell animation, Tinkerbell's flight around Sleeping Beauty's castle takes the viewer through generations of family entertainment. The design won an Emmy Award for Outstanding Main Title Design.

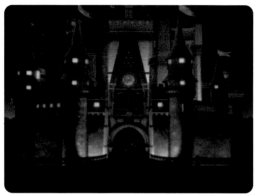
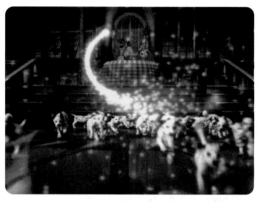
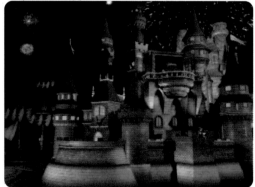
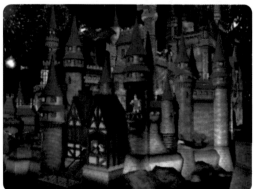
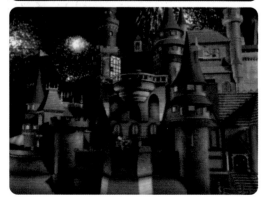

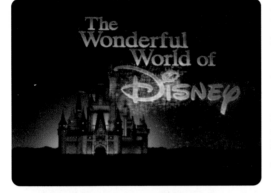

DESIGNER > Kasumi Mihori CREATIVE DIRECTORS > Kasumi Mihori PRODUCER > Toby Keil
ACCOUNT MANAGER > Marty Wall LIVE-ACTION PRODUCER / DIRECTOR > Doug Lay PRODUCTION MANAGER >
Karen Olender PRODUCTION COORDINATOR > Ken Kern DIRECTOR OF PHOTOGRAPHY > Ted Cohen
3-D ANIMATOR > Helium Productions HENRY ARTISTS > John Ciampa, Karen Henry

TF! JEUNESSE

TF! Jeunesse (Youth) is a block of children's programming for kids aged six to twelve on the French network TF1. The On-Air Promotional Toolkit uses consistent color identification, typography, painted background treatments, and the graphic forms of the logo to create a varied yet consistent universe for the needs of TF! Jeunesse self-promotion.

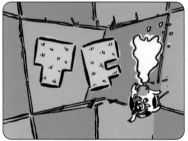

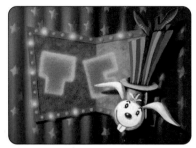
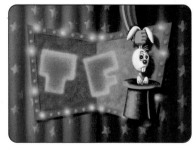

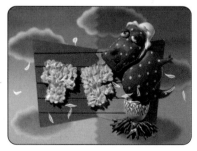
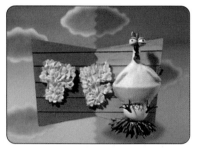

DESIGNER > Judy Korin **CREATIVE DIRECTOR >** Judy Korin **PRODUCERS >**
Kathleen Keresey , Jim Moran **ACCOUNT MANAGER >** Patty LaVigne **3-D ANIMATOR >**
Sparx* **AFTER EFFECTS >** Sam Devitt **ANIMATION >** Spontaneous Combustion
FLAME ARTIST > Ash Meer **MUSIC & SOUND >** La Belle Quipe

SPIN CITY—MAIN TITLE

The concept for the main title of this political sitcom involves capturing the energy of New York City. Edited to a snappy harmonica melody, the *Spin City* logo becomes a window for footage as images change both within letters of the logo and outside of them. Shots of the cast in everyday scenarios are intercut with the quirky New York footage to create a "Where's Waldo?" effect.

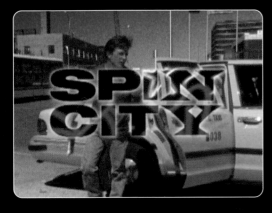

DESIGNER / DIRECTOR > Kasumi Mihori **CREATIVE DIRECTOR >** Jim Kealy **PRODUCER >** Sari Rosen **EXECUTIVE PRODUCER >** Ed Sullivan **GRAPHICS COOR-DINATOR >** Dee Dee Li **LIVE-ACTION PRODUCER >** Susan Harris **DIRECTOR OF PHOTOGRAPHY >** Tom Camarda **HENRY ARTIST >** Paul Geiger **COPY EDITOR >** John Kyd

DESIGNER > Suzanne Kiley **PRODUCER >** Kirk Cameron
EXECUTIVE PRODUCER > Billy Pittard

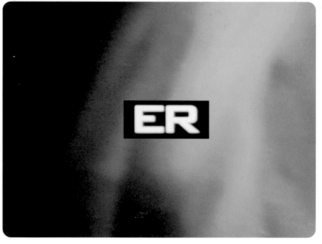

ER — MAIN TITLE

The main title of the television medical drama *ER* shows the intense conditions under which
emergency room personnel work while introducing the main characters and their relationships.
The design won the Emmy Award for Outstanding Main Title Design.

SKY PREMIER — NETWORK PACKAGE

The ultimate home-entertainment experience and the decisive leader in big hit movie service, SKY Premier delivers the best movies the world has to offer. *The Saturday Night SKY Premier Movie* open precedes the biggest of blockbuster movies offered by the network.

The stars of these IDs and opens are the film goddesses, high up in the clouds amid giant filmstrips. These ladies evoke a sense of mystery and awe as they majestically unfurl a magical draping fabric. Their image and postures intentionally resemble the many statuettes that symbolize award-winning excellence in the entertainment industry.

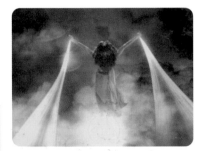

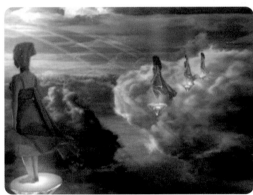

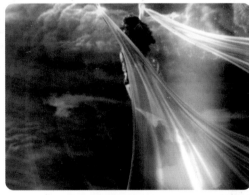

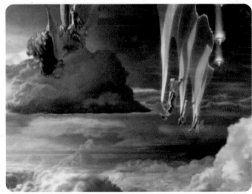

DESIGNER > Earl Jenshus **CREATIVE DIRECTOR >** Jim Kealy **PRODUCER >** Kevin Aratari **ACCOUNT MANAGER >** Marty Wall **GRAPHICS COOR-DINATOR >** Gilda Reinert **LIVE-ACTION PRODUCER >** Susan Harris **PRODUCTION MANAGER >** Chris Borden **PRODUCTION COORDINATOR >** Denise Berry **DIRECTOR >** Earl Jenshus **DIRECTOR OF PHOTOGRAPHY >** Roberto Schaefer **3-D ANIMATOR >** Helium Productions **MAC ARTIST >** Earl Jenshus **HENRY ARTIST >** Paul Geiger **COPY EDITORS >** John Kyd, Terry Paul **EFFECTS SUPERVISOR >** Michael Hertog **FLAME ARTIST >** Rene Simen **SECOND UNIT DIRECTOR OF PHOTOGRAPHY >** Tom Camarda

V H 1 — IDs

VH1 needed a cohesive look for a channel representing all different types of music. Pittard Sullivan developed a concept that allowed for the representation of all types of music, while at the same time being irreverent and playful. The IDs capture the raw feeling of Rock 'n Roll.

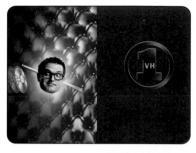

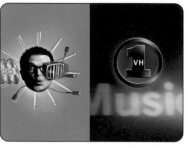

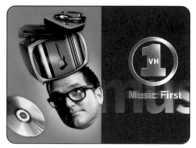

DESIGNER > Matthieu Le Blan **CREATIVE DIRECTORS >** Dale Everett, Lauri Jones **PRODUCER >** Sari Rosen
ACCOUNT MANAGER > Marty Wall **GRAPHICS COORDINATOR >** Sharon Horan **LIVE-ACTION PRODUCER >**
Teresa Antista **PRODUCTION COORDINATOR >** Shiela Conlin **DIRECTOR >** Matthieu Le Blan **DIRECTOR**
OF PHOTOGRAPHY > Mark Schumaker **3-D ANIMATOR >** Jason Rapp **MAC ARTIST >** Jeremy Alcock
HENRY ARTIST > John Ciampa **FLAME ARTIST >** Rene Simen **AFTER EFFECTS ARTISTS >** Steven Dudeck,
Jeremy Alcock **VISUAL EFFECTS >** John Ciampa

THE ART OF TELEVISION

"I never intended to become a firm," Patrick McDonough says about his six-year-old company, PMcD Design. But after having created outstanding graphics packages for the Barcelona Olympics and the Super Bowl for NBC Sports as a freelancer, he gained the attention of ESPN2. The sports broadcasters were interested in having Patrick design the on-air graphics package for the network—with one requirement: they wanted to work with a firm. Although Patrick loved the freedom, diversity, and flexibility of freelancing, the opportunity to launch a network was a prospect he could not refuse.

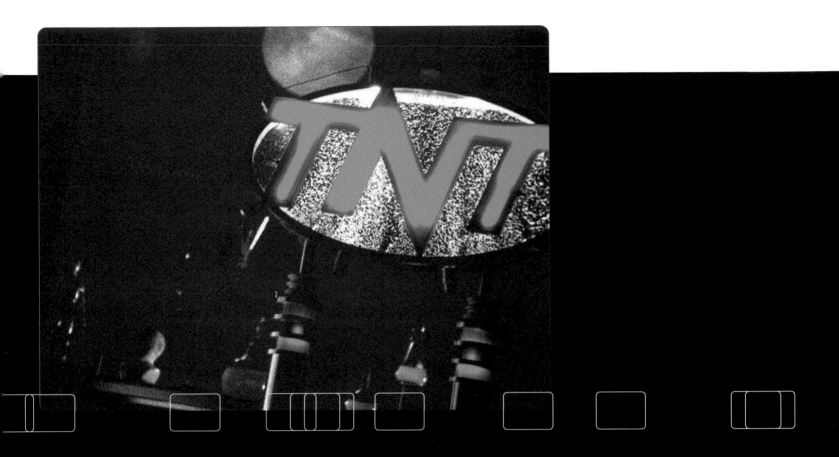

As a result, he created PMcD Design to be "a place that I could stand working at, to fit the way that I prefer to work as well as the people who work with me." The ESPN2 graphics were well-received, and he describes the experience of starting his firm in order to produce the project as "painless," due in part to the open and trusting relationship he developed with ESPN2. "Their people were not afraid to make decisions and responded well to the design directions and the concepts behind them."

Patrick says that while the firm's creative process is unique to every project, the common starting point is working to get clients to talk about who they are and who they are trying to speak to with their communications. "We do our homework. After talking with a client and doing research, we start to assemble what becomes our initial presentation. This doesn't take the form of storyboards— it is usually visual reference, fonts, colors, etc. Our initial presentations are based on an overall direction, feelings that we can get a client to look at and respond to."

NATIONAL GEOGRAPHIC CHANNEL—LAUNCH

The National Geographic Channel is a network based on the popular magazine. The goal for PMcD was to create a powerful signature and branding for the network as a "world channel." The design expresses the character of a century-old institution that is all about taking risks. The yellow border trademark serves as an integral element in the channel's brand identity. It enters into three dimensions and interacts with the content as a physical object. This symbol is used in juxtaposition with culture, exploration, adventure, and natural history.

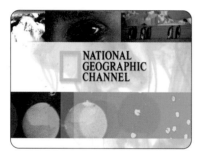

CREATIVE DIRECTOR > Patrick McDonough, PMcD Design **DESIGNER >** Patrick McDonough, PMcD Design **EXECUTIVE PRODUCER >** Dana Bonomo, PMcD Design **DESIGNERS >** Michael Grana and Steve Tozzi, PMcD Design **PRODUCER >** Joanne Tolkoff, PMcD Design **CLIENT >** National Geographic > Mary Hicks, creative director **CREATIVE DIRECTOR / WRITER >** Walter Thomas, Air Force One **LIVE-ACTION DIRECTOR >** Trez Bayer, Air Force One **MUSIC >** Elias Associates, NYC

T N T — REDESIGN

To redesign TNT, a network that features a wide variety of programming, PMcD developed its concepts around featuring the logo as a hero in a variety of genre-based settings that show viewers what they are watching in a direct, honest way. IDs are genres of TNT programming: westerns, action, pop, sci-fi, and the TNT "Hero." In each identity, the logo appears as a large sign complete with a distinctive environment and sounds.

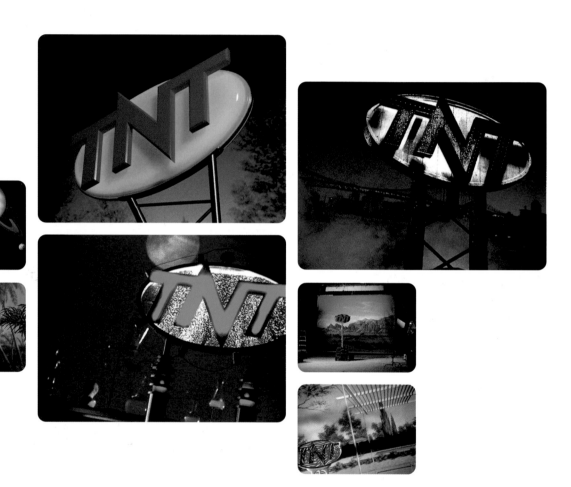

CREATIVE DIRECTOR > Patrick McDonough, PMcD Design **DESIGNER >** Patrick McDonough, PMcD Design **EXECUTIVE PRODUCER >** Dana Bonomo, PMcD Design **CLIENT >** TNT Network > Brad Siegel, president; Andrea Taylor, VP creative services **LIVE-ACTION DIRECTOR >** Glenn Lazzaro, Division 6 **EXECUTIVE PRODUCER >** Susie Shuttleworth, Division 6 **MUSIC >** Elias Associates, NYC **EDITOR >** Glenn Lazzaro, Division 6

CREATIVE DIRECTOR > Patrick McDonough, PMcD Design **EXECUTIVE PRODUCER >**
Dana Bonomo, PMcD Design **PRODUCER >** Diana Lochridge, PMcD Design **CLIENT >**
AMC > Stuart Selig, Director On-Air Promotion **LIVE ACTION DIRECTOR >** Glenn Lazzaro
DIRECTOR OF PHOTOGRAPHY > Russell Lee Fine **MUSIC >** Elias Associates, NYC
VISUAL EFFECTS COMPANY > Black Logic, NYC

AMERICAN MOVIE CLASSICS—
REDESIGN

For American Movie Classics (AMC), a channel that features classic American films, the goal was to
attract a younger audience while not alienating the traditional viewer base. PMcD took a crisp, bright
approach with a modern influence to cast the channel in a contemporary light. The solution is filmic,
smart, and simple.

E S P N 2 — **LAUNCH**

The ESPN2 graphics identity broke significantly from the ESPN identity and traditional television sports design. A cooler, faster, contemporary look was developed to create a network package geared to the Generation-X viewer. PMcD approached ESPN2 creatively as "The wild son of ESPN."

CREATIVE DIRECTOR > Patrick McDonough, PMcD Design **EXECUTIVE PRODUCER >** Scott Danielson, PMcD Design **DIRECTOR >** Scott Danielson, PMcD Design **CLIENT >** ESPN > Noubar Stone, creative director **DESIGNER >** Dale Robbins **MUSIC >** Elias Associates, NYC **VISUAL-EFFECTS EDITOR >** Michel Suissa, Tape House Digital **EXECUTIVE PRODUCER >** Karen Stewart, Tape House Digital

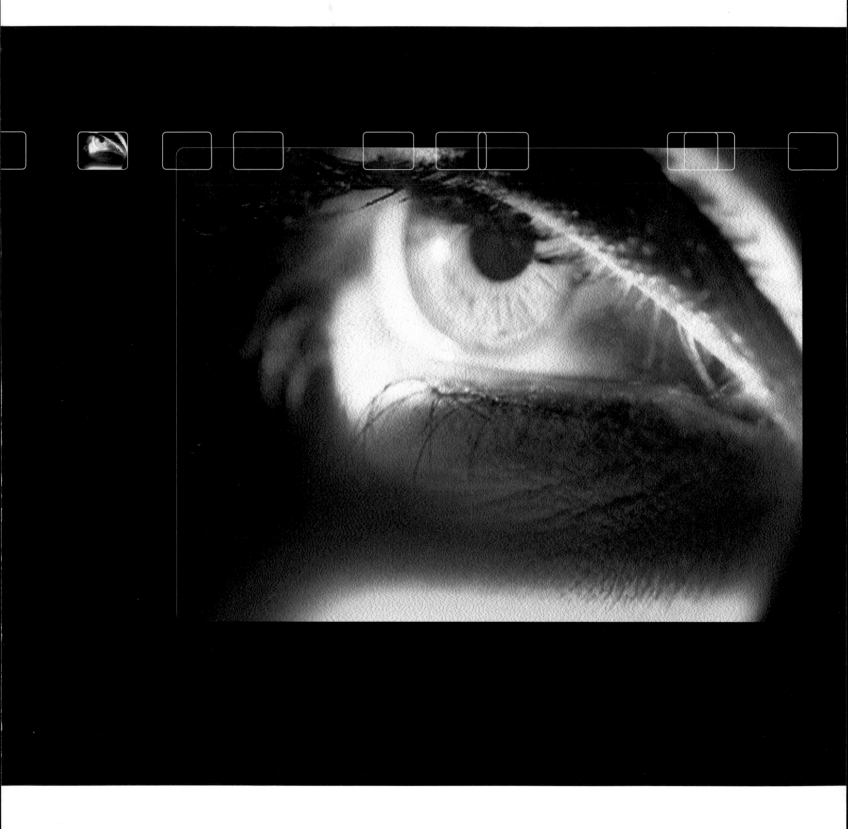

AN UNAMBIGUOUS STYLE

Velvet is one of Germany's leading design studios. Creative designers and directors who came from TV channel-design departments established the firm in 1995. The Munich-based company is marked by an unambiguous style and outstanding creative energy. Its designers have produced award-winning channel-identity branding and rebranding for many leading German and international channels. Drawing on the firm's experience in broadcast design, Velvet has broadened the scope of the firm's work and reputation into the world of advertising, by now producing commercials and corporate films.

The firm's philosophy stresses teamwork, flexibility, and the ability to adapt to the specific needs and requirements of every client and target audience. Working within small and very specialized creative teams, these project-related experts cover all stages of the project from the early creative and conceptual phases to the finished product. The designers are skilled with a wide enough variety of production tools to offer the capability of producing work from shoot to postproduction, in-house, on the client premises, or at a postproduction facility. This "all-in-one" working principal enables the firm to maintain scrupulous control at all stages of the process, therefore guaranteeing control over the quality of design that characterizes Velvet's work and reputation.

SKY SPORTS—IDS 1998

Velvet created the station design package for the three sports channels SkySports 1-3 of the British pay television Sky. Emotions instead of action show the body language of sports: victory and defeat, satisfaction and frustration, concentration and relaxation.

CREATIVE DIRECTORS > Matthias Zentner, Andrea Bednarz, Conny Unger **ART DIRECTORS >** Matthias Zentner, Andrea Bednarz, Conny Unger **DESIGN >** Matthias Zentner, Andrea Bednarz, Conny Unger **DIRECTOR >** Matthias Zentner **CAMERA >** Dieter Deventer **PRODUCER >** Ralph Strachwitz **MUSIC >** Natural Sound, London **CLIENT >** Sky > Noel Kearns, creative director

CREATIVE DIRECTORS > Andrea Bednarz, Matthias Zentner **ART DIRECTORS >** Simone Haberland, Daniel V. Braun, Andrea Bednarz, Matthias Zentner **DESIGN >** Simone Haberland, Daniel V. Braun, Andrea Bednarz, Matthias Zentner **CLIENT >** Universal / 13th Street > Michael Barry, Frauke Flosbach, creative directors; Matthias Zentner, director

13TH STREET — PROMO PACKAGE

Velvet created an entirely new promotion package for the all-European station of Universal's 13th Street, combining some forty individual graphic elements.

AUDI A4 V6 TDI — SOFA

An automobile commercial for Audi's new A4 V6 and a new approach in TV advertising for Audi: Producing a forty-second spot without using one second of filmed car footage, just a photo during two seconds. The commercial communicates one emotion: the feeling of this new V6 car's acceleration. Filmed backgrounds were combined with type animation to create the impression of a tunnel.

C N N — NETWORK IDS

"First stage of CNN International's new on-air look, in the most comprehensive design review the network has ever undertaken in its fourteen-year history" (CNN press release). A macro world of natural elements joins the common denominator of the cultures of 212 countries to which CNN supplies the latest news.

CREATIVE DIRECTORS > Christian Tyroller, Matthias Zentner, Andrea Bednarz, Conny Unger **ART DIRECTOR >** Christian Tyroller **DESIGN >** Christian Tyroller **CLIENT >** CNN > Morgan Almeida, design director

VOX—FIT FOR FUN

The successful German print magazine *Fit for Fun* was transferred to television on VOX. Velvet created the total package design, including opening titles, break bumpers, set design, and other visual elements.

CREATIVE DIRECTOR > Stefanie Pfeffer **DIRECTOR >** Matthias Zentner **ART DIRECTORS >** Stefanie Pfeffer, Matthias Zentner, Andrea Bednarz **DESIGN >** Stefanie Pfeffer, Matthias Zentner, Andrea Bednarz **CAMERA >** Thorsten Lippstock

CREATIVE DIRECTOR > Conny Unger DIRECTOR > Andreas Link
ART DIRECTORS > Daniel V. Braun, Simone Fischer, Christian Tyroller DESIGN >
Daniel V. Braun, Simone Fischer, Christian Tyroller POSTPRODUCTION SUPERVISOR >
Christian Kuenstler CLIENT > ProSieben > Markus Schmidt, creative director

PROSIEBEN — HISTORY

Velvet created the total package design for a new show on ProSieben, which is dedicated to science, culture, and history.
The design features historical milestones newly interpreted, using state-of-the-art postproduction.

ZDF KINOWELT

With *ZDF Kinowelt*, the German television station introduced a label for blockbuster movies like *Casino* that were shown once a month on Saturday. The interpretation of this label uses key visuals of the "big cinema" of the twenties.

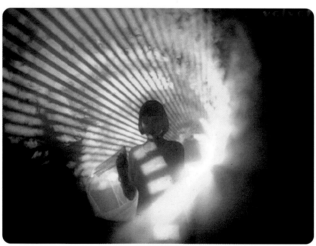

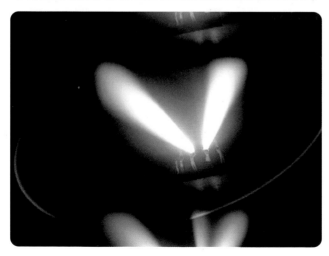

CREATIVE DIRECTORS > Stefanie Pfeffer, Matthias Zentner
ART DIRECTORS > Stefanie Pfeffer, Matthias Zentner DIRECTOR > Matthias Zentner DESIGN > Stefanie Pfeffer, Matthias Zentner
ZDF CORPORATE DESIGN > Anja Stöffler, Alex Hefter CAMERA > Tom Fährmann PRODUCER > Tobias Bösing

PROSIEBEN — NEWS

This show-opener is part of the total package redesign for ProSieben News. The style is clear, dynamic, and journalistic.
It features a combination of shooting, 3-D-animation, and graphic textures.

CREATIVE DIRECTORS > Conny Unger, Andrea Bednarz **ART DIRECTORS >** Daniel V. Braun, Simone Fischer, Christian Tyroller **POSTPRODUCTION SUPERVISOR >** Christian Kuenstler **CLIENT >** ProSieben > Marcel Mohaupt, head of marketing; Markus Schmidt, creative director **3-D ANIMATOR >** Jurgen Schopper, ARRI **PRODUCER >** Tobias Bosing

FILM

THE MOVIE BEFORE THE MOVIE

First impressions are a powerful force in human nature. From the moment in which we are introduced to something new, our perceptions are shaped by intangible visual and auditory cues that operate on both a conscious and a subliminal level to help us process, label, and categorize information. For film audiences, after the words *Feature Presentation* have flashed on the screen and the studio logo has faded, there is a moment of quiet anticipation when the stage is set for members of the audience to establish their first impression of the film.

Some filmmakers want those first moments to be breathtaking; they create titles that kickstart the adrenaline glands and thrust the viewer into the film's momentum. Some filmmakers raise a question or provide a clue. Other directors prefer that a title sequence be almost invisible, seamlessly and quietly woven into the beginning of the film.

The past few years have seen a revival of interest in the art and business of film-title design. Many industry observers acknowledge Kyle Cooper's dark and powerful title treatment for the serial killer film *Seven* as having single-handedly revived interest in the art form. *Seven* contained a raw, textural, and kinetic energy that seemed fresh in the world of film-title graphics. Additionally, firms like Bureau and like Balsmeyer and Everett have gained notice for outstanding conceptual designs reminiscent of the film-title master Saul Bass.

Changes in technology have helped to increase the interest level in title design as well. It was only a matter of time before the wildly experimental print work that followed the introduction of the Macintosh computer found its way onto the big screen. The wave of talented people entering the field and the incredible new desktop tools at their disposal yield the possibility of more creative (and affordable) creative experimentation than the medium has ever experienced. Before the availability of desktop video and animation packages, most title designers worked with animatics or storyboards. The final product was produced with technology available only at optical houses or computer-effects companies at a cost that left little margin for changes and creative exploration.

But the power of the personal computer and the plethora of video and animation tools available now means that creating motion graphics is as relatively affordable a creative playground as print. Working in new media has whetted the appetite of thousands of designers to create design that moves and speaks. Now they fantasize about big-screen exposure.

If only it were that simple.

While it is true that the creative energy, experimentation, and innovation at work in film-title design has energized the medium, many of the ghosts that make it a challenging and closed industry still exist. Film titles, to a large degree, are the afterthought of movie production; their typical budget was described by one practitioner as "whatever's left over after the caterer has been paid at the wrap party." The Hollywood plague of me-tooism still lurks, wherein clients want to repeat a solution that worked in the past for somebody else. Finally, while it is likely that the field will get much more creatively competitive due to the sheer number of individuals who want to work in it, the number of firms in the industry will increase at a much slower rate.

But change is on the horizon. The optical process moves closer to obsolescence with every advance in digital tools. As more designers do breakout work, respect and demand for good title design is beginning to rise in Hollywood. And as more and more designers like Geoff McFetridge (who designs film titles out of a one-person studio) throw industry convention out the window and discover new ways of working, the rules of the game can change as quickly as the flash of a frame of celluloid.

SPLIT FOCUS

Even though Balsmeyer and Everett has been producing exceptional work for thirteen years, working for directors like Spike
Lee and the Cohen Brothers, Randy Balsmeyer is constantly reintroducing the firm to clients. Balsmeyer and Everett features
what he describes as a "schizophrenic" focus on both title design work and highly technical special-effects production.
Many times a client never knows that there is another side to the firm. "In this business, producers like to peg you and say
'Oh, that's the guy that does *that* thing,' so it does get tricky when you switch hats on them."

BALSMEYER AND EVERETT

But Randy says that straddling the fence in these areas has expanded the range of possibilities for design solutions. "If you are trying to create a title sequence sitting at a computer, you might not consider putting something in front of a camera and shooting it—like actors or objects; real-life stuff. Our knowledge and experience in areas outside pure graphic design means we can bring more to the party. Having more hats makes us better designers."

For Balsmeyer and Everett, the two sides of the firm's work constantly inform and enhance each other. "The design background makes us better effects people. More than just being mechanical guys, we are able to think more conceptually, more like filmmakers. Our clients appreciate that we are thinking about the story rather than just simply approaching it as pure technicians."

INDEPENDENT — CHINESE BOX

The director of this movie wanted to give a literal tour through a Chinese box, which Balsmeyer and Everett interpreted as a maze of drawers and doors, not unlike the Russian dolls-within-dolls whose multiple layers seem endless. The camera's path travels from the inside out, showing small objects (wristwatch, amulet, key, postcard) that figure in the narrative of the film. The sequence was completely computer generated; the camera's path would have been physically impossible to achieve by filming a real prop.

DIRECTOR > Randy Balsmeyer **DESIGNER >** Randy Balsmeyer
ANIMATORS > Daniel Leung, Matt McDonald, Amit Sethi **DIRECTOR >**
Wayne Wang **PRODUCERS >** Wayne Wang, Lydia Dean Pilcher, Jean-Louis Piel

UNIVERSAL PICTURES — CLOCKERS

For the title sequence of this movie, the goal was to evoke the underlying sense of dread and danger that is ever present within inner-city housing projects. This sequence alternates between camera moves on (staged) still photos of murder victims and live-action footage of a crowd at a crime scene. The black and yellow titles over the pictures take their cue from the familiar yellow tape that surrounds crime scenes.

DIRECTOR > Randy Balsmeyer **DESIGNER >** Randy Balsmeyer **ANIMATION CAMERAMAN >** Eric Rochow
DIRECTOR > Spike Lee **EDITOR >** Sam Pollard **PRODUCERS >** Martin Scorsese, Spike Lee, Monty Ross, Jon Kilik

DESIGNER / DIRECTOR > Randy Balsmeyer **MOTION-CONTROL PHOTOGRAPHY >** A.J. Hudson
PROPS > Werner Bargsten **FILM CREDITS >** Spike Lee, writer, producer, director **EDITOR >** Sam Pollard

UNIVERSAL PICTURES—JUNGLE FEVER

For the film *Jungle Fever*, Balsmeyer and Everett used motion-control photography of mock street signs to present the film's credits and titles. The shots were matted onto cityscapes to reflect the film's urban setting.

UNIVERSAL PICTURES — THE BIG LEBOWSKI

The challenge was to create a title sequence for this movie, a modern tale of the Old West, with a bowling alley as a central meeting place. A clash of typefaces and textures (wood and chrome) was employed to illustrate the contrast of cultures represented in the film. The main title lifts up in 3-D to reveal a view of the bowling alley from the pinsetter's perspective.

DIRECTOR > Randy Balsmeyer **DESIGNER >** Randy Balsmeyer **ANIMATORS >** Matt McDonald, Gray Miller, Amit Sethi
FILM CREDITS > Joel Coen, director; Ethan Coen, producer; Universal Pictures, Studio

BOLD AND BEAUTIFUL

BUREAU, formed in 1989 by Marlene McCarty and Donald Moffett, is a transdisciplinary design studio and ongoing collaboration. BUREAU historically has traversed the boundaries between artist, designer, and author, seeking languages (visual and spoken) that can affect specific contemporary issues and trends.

The firm is identified most often in the world by its body of socially engaged work. Its history in this area is long, rich, and varied. Recently, BUREAU's more significant contribution to the design world has been in the territory of film-title design.

BUREAU's first title design was for *Swoon*, a film by Tom Kalin. BUREAU asked to do the titles. "We had no idea what we were talking about," Marlene recalls. But the success of those titles and a few others designed for independent films soon got its designers word-of-mouth buzz that said, "if you are doing an independent film, you want to talk to BUREAU about designing your titles." BUREAU has amassed an impressive reel of work for these films, featuring bold, graphic typography that is both sophisticated and playful.

Film-title design constitutes only a small percentage of the firm's work, which consists mainly of print design: "We only do one to three titles a year; we do more print than anything. Some people won't work with us because we are not specialized. On the other hand, we have always dived in with the attitude that 'design is the most important thing.' It's not about how much technology you own or how well you use the effects. We survive on design because we have worked on so many projects with minimal budgets. Once you get into film, everything you do that adds effects adds money. We've relied on bold designs to get us through."

BUREAU has worked hard to convince the independent film community that title design is an important part of producing a film. The firm played a large role in creating an awareness of title design among independent filmmakers. The day of this interview, Marlene received a call from a production company that in its early stages of the budget already had put in a line item for title design: "I thought to myself 'wow, we've come a long way. People know that design exists.'"

GOOD MACHINE / KILLER FILMS PRODUCTIONS—OFFICE KILLER

In photographer Cindy Sherman's satire of the B-movie killer/thriller genre, the typography distorts itself against objects and backgrounds of an office murder scene.

TITLE DESIGN > BUREAU
DIRECTOR > Cindy Sherman

AMERICAN PLAYHOUSE INTERNATIONAL /
THE SAMUEL GOLDWYN COMPANY—
I SHOT ANDY WARHOL

I Shot Andy Warhol restages the revenge of feminist Valerle Solonas on the Warholian empire, targeting the pop artist himself.
The main title scales larger than the screen, providing a blood-red field for the harsh, typewriter-style typography.

TITLE DESIGN > BUREAU
DIRECTOR > Mary Harron

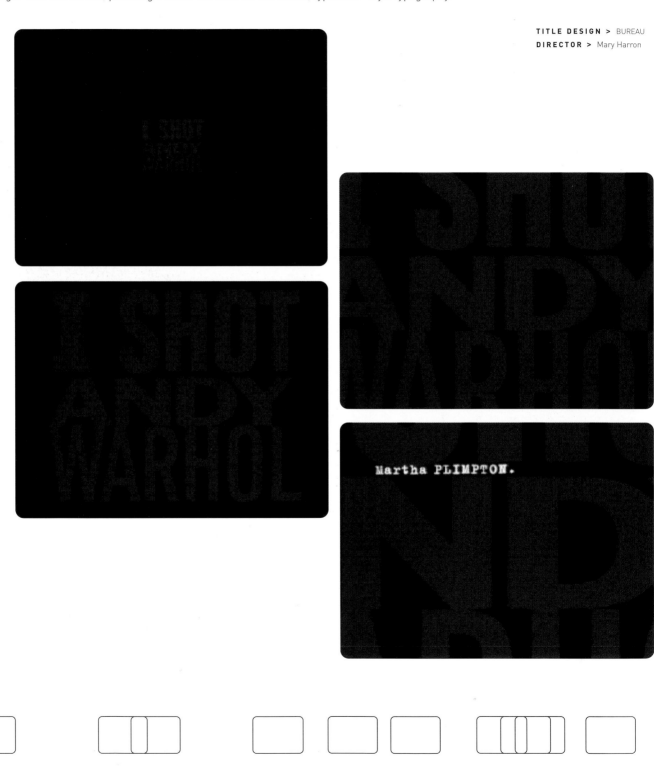

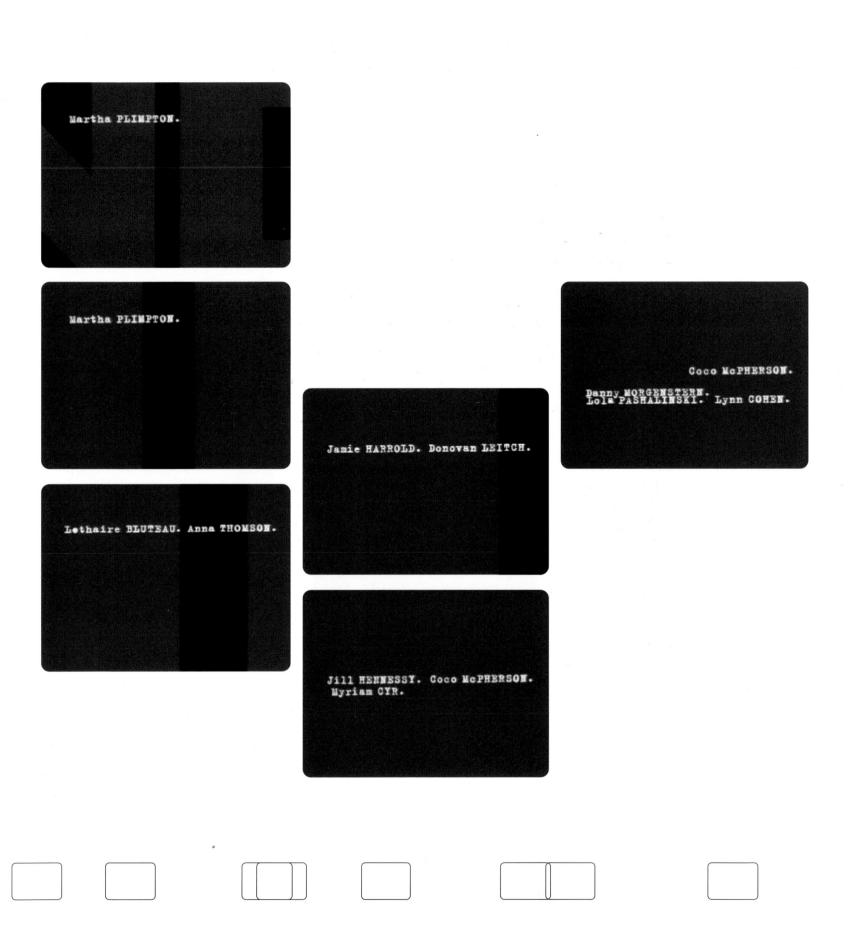

FOX SEARCHLIGHT / GOOD MACHINE—
THE ICE STORM

Ang Lee's *The Ice Storm* depicts affluent families in suburban Connecticut, 1973, as each family member struggles with the social constructs of sexuality. The crises that each character coldly faces are built around the backdrop of an ice storm—a setting perfect for BUREAU's cloudy and amorphous text.

TITLE DESIGN > BUREAU **DIRECTOR >** Ang Lee

MIRAMAX / ZENITH PRODUCTIONS / KILLER FILMS PRODUCTIONS / SINGLE CELL PICTURES — VELVET GOLDMINE

Velvet Goldmine is a glam portrayal of the seventies. The typefaces and flamboyant color scheme reflect the ostentatious fashions of the period.

TITLE DESIGN > BUREAU **DIRECTOR >** Todd Haynes

Written, Directed
and
Co-produced
by
↓
TOM KALIN

RICHARD LOEB
DANIEL SCHLACHET

NATHAN LEOPOLD, JR.
CRAIG CHESTER

FINE LINE FEATURES — SWOON

This film interprets the infamous Leopold and Leob murder case where defense lawyer Clarence Darrow used the defendant's homosexuality as evidence of insanity. The title treatments incorporate arrows as a device that lends the design an archival quality.

TITLE DESIGN > BUREAU **DIRECTOR >** Tom Kalin

Cast

IN ORDER OF APPEARANCE

GERMAINE REINHARDT	VALDA Z. DRABLA
SUSAN LURIE	NATALIE STANFORD
VENUS IN FURS DIVAS	ISABELA ARAUJO
	JILL "SPANKY" BUCHANAN
	MONA FOOT
	TRASH
	TRASHARAMA
	NASHOM WOODEN
FACTORY WORKMAN	PETER BOWEN
IVORY	RYAN LANDRY
MONA FOOT	MONA FOOT
ELEKTRA LUXE	CHRISTOPHER HOOVER
BOBBY FRANKS	PAUL CONNOR
IRVING HARTMAN	BRENT CHARLETON
LITTLE BOY IN PARK	CHRISTOPHER CANGELOSI
COUNTRY WORKMEN	DICK CALLAGHAN

	CARLOS RODRIGUEZ
	ELION SACKER
	EMMITT THROWER
	ERIC J. WIGGINS III
SVEN ENGLUND (CHAUFFEUR)	KEN HOWARTH
MR. FRANKS	BARRY LIEBOWITZ
MRS. FRANKS	JUDITH BOXLEY
WORKMAN IN MARSH	JULIAN MARYNCZAK
ORNITHOLOGIST	DANIEL HAUGHEY
MAN WITH NEWSPAPER	JOHN ROWAN
MR. LOEB	STANLEY TAUB
ALLAN LOEB	ROBERT AUSTIN
MRS. LOEB	BARBARA BLEIER
MIKE LEOPOLD	ED ALTMAN
DETECTIVE SBARBARO	JOHN A. MUDD
NIGHT DESK OFFICER	ROBERT SULLIVAN
NIGHT COP	VERNE F. HOYT
NIGHT DETECTIVE	PEPE VIVES
INTERROGATION COP	JAMES CUMMINGS
MR. LEOPOLD	MALCOLM A. BEERS, JR.

CLARENCE DARROW	ROBERT READ
JUDGE CAVERLY	PAUL SCHMIDT
DOCTOR HULBERT	RICHARD ELOVICH
REPORTERS	CHRISTIE MACFADYEN
	ROBERT McKANNA
	BOBBY REED
BAILIFF	MARK SIMPSON
PRISON BARBER	JIM CRAWFORD
JAMES DAY	GLENN BACKES
MEAN PRISON GUARD	RAY WASIK
CLINIC DOCTORS	JEAN CLAUDE MONFORT
	MICHAEL NESLINE
	RICHARD R. UPTON
	WILLIAM WALTERS
WARDEN	BURT WRIGHT
FATHER WEIR	PAUL RUBIN
INTERROGATION COP	GARY LAMADORE
RADIO ANNOUNCER	RICHARD SCHECHNER
GENE LOVITZ	PHIL STANTON
COURTROOM EXTRAS	DEAN C. BLANCO

ISLET FILMS — POSTCARDS FROM AMERICA

Postcards From America is based on the writings of the late David Wojnarowicz, a radical '80s artist struggling with the effect of AIDS on his world. The title actively fills the screen with oversized graphics.

TITLE DESIGN > BUREAU **DIRECTOR >** Steve McLean

UNCONVENTIONAL WISDOM

The conventional wisdom in film-title design says that the art is best left to a few highly specialized firms that have the manpower, relationships, and resources to make this difficult business profitable and satisfying.

Geoff McFetridge, founder and sole employee of Champion Graphics, is too busy to listen to conventional wisdom; he is immersed in building what he refers to as "a new definition of a film-title designer." For Geoff, film-title design is not a specialty but rather just one of the more challenging and interesting media among the many in his eclectic mix of projects. He might work on a mainstream Hollywood feature title design at the same time he is designing graphics for a T-shirt company.

Keeping his project mix diverse is an important factor that Geoff feels helps him in creating his film work. "The genesis for any work I've done has come from traditional print design. In title design, I am further elaborating on ideas I have been developing in my print work. That's where I came from. Everything I try to do, I try to be fluid. I always want to let the stuff I've done influence the stuff I'm going to do."

While Geoff is well-versed in animation and computer graphic tools, it is largely his hand-rendered work that lends his most interesting film-title work a raw, kinetic feel. It is the antislick nature of the work so rare in film-title design that makes his designs so refreshing. "These days, drawing is like a trick," says Geoff. "You don't let anybody see you do it and then people say, 'Wow, how did you get the computer to do that?'"

Geoff is pragmatic about making sure that film-title design remains a satisfying medium in which to work. "The way I'm interested in working is one-on-one with directors I respect, who want something cool. And they want to work directly with an individual whom they can trust. There is definitely a way to make it work and, in a way, I'm figuring out what that is."

JAMES REDFORD FOUNDATION—**FLOW**

For the main titles for a film on organ donation with a rave/DJ theme, Geoff used layers of typography and abstract elements cut in with footage from the film itself.

DESIGNER / ANIMATOR > Geoff McFetridge
DIRECTOR > Dave Kebo
ANIMATOR > Johannes Gamble

DESIGNER / ANIMATOR > Geoff McFetridge
DIRECTORS > Spike Jonze, Rick Howard

For the opening sequence for *The Virgin Suicides*, handwritten names and seventies notebook lettering are employed to introduce the film's main characters. The main title and signatures mimic notebook or diary doodles and are meant to evoke a typographic teenage daydream.

DESIGNER / ANIMATOR > Geoff McFetridge
DIRECTOR > Sofia Coppola

CASTLE ROCK—ZERO EFFECT

For the title sequence for the film *Zero Effect*, signatures and forgeries of signatures play with the idea of identity. Using graphic representations of moments from the film blown up to unnatural proportions, the audience is introduced to the film's underlying themes.

EDITED BY **TARA TIMPONE**

DIRECTOR OF PHOTOGRAPHY **BILL POPE**

DESIGNER / ANIMATOR > Geoff McFetridge **DIREC-**
TOR > Jake Kasdan
ANIMATOR > Johannes Gamble

MOVING PICTURES BY DESIGN

The world of design recognizes Saul Bass and Pablo Ferro as pioneers of the conceptualized and inspired film-title design. But it was brothers Robert and Richard Greenberg, founders of R/Greenberg Associates, who turned film-title design and motion-graphic design into an industry. Their firm was among the first to approach film-title design as a collaboration of creative talent and technology. The firm broke new ground, creatively producing an impressive body of legendary film design. It also generated many technical innovations that changed the industry and was fertile breeding ground for outstanding talent in film and television design.

Kyle Cooper, Garson Yu, Randy Balsmeyer, and Mimi Everett, most of today's top film-title designers, as well as many broadcast designers and directors, have at one time been designers at R/GA. According to Robert Greenberg, the success of these individuals documents how the Bauhaus-inspired culture of R/GA has developed and fostered conceptual designers who can think in motion.

"Long before it was a creative-industry cliché, we worked collaboratively. We came up with a design process where people worked together and share the credit. It's a perfect example of how well it works to see how many talented people the process developed. It also creates a situation where people eventually grow to the point that they will eventually leave and do their own thing, and at the end of the day, that's probably what they should do."

Robert has seen firsthand how the increased pressure on the marketing of a film has changed the medium for better and worse. On the positive side: "I think that new directors today are marketing-savvy. They realize that half the success of making a film is marketing it. They see the important value in having a great trailer and a great opening as part of the marketing of the film." On the negative side: "film marketing used to be an integrated campaign, where we would design the logo, the one sheet (poster), the trailer, and the opening. But today it's much more bureaucratic, with different components being handled by different departments."

R/GREENBERG
ASSOCIATES

For Robert, the fact that the work could no longer be handled with an integrated approach was one reason behind his sale of R/GA LA, the film-design unit of the firm that he sold in 1997 and now is known as Imaginary Forces. The firm has shifted its focus to interactive work, which Robert sees as much more integrated into the work of the entire firm as television moves toward convergence.

The firm is starting to work back into the feature-film business again after having worked on more than 400 feature films. But Robert says that he is most inspired by the interactive work, and he sees R/GA assuming an innovative and leading role in the industry.

"The Internet reminds me of inventing and taking a leadership role similar to what we've been able to for television and feature film. I am able to do that again in the interactive space, so it's really exciting. That's where we want to be."

NEW LINE CINEMA — ISLAND OF DR. MOREAU

For this H.G. Wells horror film about an island of half-animal, half-human genetic mutations, microscopic scientific imagery and footage of unidentifiable pupils are intercut to the rhythm of drum and bass music loops at a rapid pace. The composited typography seems mutated, spliced, and reorganized, thereby alluding to the film's theme.

TITLE DESIGN > R/Greenberg Associates

PARAMOUNT PICTURES—

THE UNTOUCHABLES

Long, ominous shadows that appear to be men walking in line are revealed as the towering three-dimensional title treatment evokes the gangster noir of the film's theme and the larger-than-life persona of Elliot Ness vs. Chicago's prohibition-era bootleggers.

TITLE DESIGN > R/Greenberg Associates

TWENTIETH CENTURY FOX—
TRUE LIES

For the James Cameron film *True Lies*, the three-dimensional type treatment of the word *true* rotates to reveal the word *lies* in the negative space of the profile view. This image functions as a visual representation of the oxymoron title and of the film's subject, which is played out through the lives of a married couple unaware of the double life each leads through the world of espionage.

**TITLE DESIGN > ** R/Greenberg Associates

TWENTIETH CENTURY FOX—RISING SUN

For this film about a high-level murder cover-up inside of a Japanese multinational corporation, simple typography was superimposed over an elegant Japanese calligraphic symbol that scales in size and fades behind a photographic version of the Japanese Rising Sun.

TITLE DESIGN > R/Greenberg Associates

PARAMOUNT PICTURES — MISSION IMPOSSIBLE

For this big-screen update of the classic '60s television show, the title sequence borrows images such as the burning fuse and file photos from the original. Yet it updates the original with frenetic jump-editing, computer-distorted imagery, and a contemporary logo treatment. The sequence effectively set the tone for a hipper, larger update of the original while retaining the trademark appeal.

TITLE DESIGN > R/Greenberg Associates

A BRIAN DE PALMA FILM

NEW LINE CINEMA — SEVEN

Seven is dark film about a serial killer who leaves cryptic, biblically inspired crime-scene clues with his victims. This treatment influenced by "outsider-art" used distorted, scratched, and grungy typography, shaky camera movement, and glimpses of seemingly disturbing imagery to create a sequence that is as creepy as it is fascinating.

TITLE DESIGN > R/Greenberg Associates

OBSERVATION, UNDERSTANDING, IMAGINATION

Even if you don't go to the movies, you probably have seen the work of Garson Yu. Between his recent work with yU+ Co. and the material he was responsible for while with Goodspot and Imaginary Forces, Garson has over twenty film titles to his credit, including the trailer for *Saving Private Ryan* and the main titles for films such as *Twister*, *Spawn*, *G.I. Jane*, *Enemy of the State*, and *The Joy Luck Club*. But it is his smallest-sized animation, a mere forty-by-forty pixels, that gets the attention of millions of people around the world every day. Yu designed the tiny Netscape comet animation in the corner of the popular browser that instantly lets users know that they're connected to the World Wide Web.

For Garson, whether a design is measured in pixels or feet, the creative challenge is the same. "You can still tell a story, even in something as short as thirty-six frames, like the Netscape animation. It is always the same."

In the case of film work, many times Garson faces the challenge of telling
a story without actual footage with which to work. Sometimes the footage
isn't available because the film hasn't been finished. Other times, such
as when Garson designed the titles for *Saving Private Ryan*, directors are
opposed to revealing a single frame until shortly before the release of
the film. For Garson, these situations are more challenging and more
gratifying because they usually result in a highly conceptual "minimovie."

Garson's creative process always involves observation, understanding, and imagination.
"Sometimes you look at something like a raindrop and you see something else—that's inspiration.
That inspiration can be something quite important and, once you understand what it is, you can
turn it into something that is appropriate for a design."

While Garson approaches his work artistically, he sees the role of a film-title sequence as similar
to that of good packaging design. "The content of a movie does not depend on a title, but a good title
design can set up a tone and mood for the audience to prepare to enter this fantasy, this dreamland.
It helps them get into the experience."

DOLBY LABORATORIES — RAIN

When designing a theatrical logo to introduce Dolby Laboratories' revolutionary theatrical sound system, yU+co. was challenged to present the logo in an innovative and elegant way. They created a dramatic, subtle and moving experience that takes the audiences from inside the muffled walls of a raindrop to inside of a puddle from where they look up at golden concentric circles of falling water.

PRODUCTION COMPANY > yU+co. **CREATIVE DIRECTOR >** Garson Yu **DESIGNER >** Garson Yu **PRODUCER >** Grace Huang **STORYBOARD ARTIST / DESIGNER >** Chad Park **EDITOR >** Eric Buth **2-D ANIMATORS / DESIGNERS >** Steve Kusuma, Yiing C. Fan **SPECIAL-EFFECTS CINEMATOGRAPHY >** Dan Schmidt, Stargate Films **DIGITAL-EFFECTS COMPOSITOR >** Nathan McGuinness

JERRY BRUCKHEIMER FILMS—
ENEMY OF THE STATE

Enemy-of-the-State is a high-tech thriller film about a government agency abusing technology to invade the privacy of citizens. yU + co. set cryptographic-styled typography against a hyperactive backdrop of satellite photography, video surveillance footage, infrared photography, government buildings, and surveillance personnel.

PRODUCTION COMPANY > yU+co. **PRODUCER** > Grace Huang
CREATIVE DIRECTOR > Garson Yu **DESIGNER** > Garson Yu **EDITOR** > Eric Buth
GRAPHIC DESIGNERS / ANIMATORS > Steve Kusuma, Yiing C. Fan, Harkim Chan

L'ARC-EN-CIEL—SUNNY SIDE UP ALBUM PROMOTION COMMERCIAL

A thirty-second spot to promote the latest album by the Japanese band L'Arc-en-Ciel, this is composed of extravagant, neo-psychedelic graphics combined with clips from the band's recent music videos for the album.

PRODUCTION COMPANY > yU+co. **CREATIVE DIRECTOR** > Garson Yu **DESIGNER** > Garson Yu
PRODUCER > Carol Wong **LIVE ACTION GRAPHIC EFFECTS PHOTOGRAPHY** > Rick Spitznass **EDITOR** > Eric Buth **GRAPHIC DESIGNERS / ANIMATORS** > Aki Narita, Steve Kusuma, Yiing C. Fan
AGENCY > Hakuhodo, Tokyo Japan; Mothers Inc., Tokyo Japan

GLOSSARY

AFTER EFFECTS (ADOBE)
> A professional yet affordable animation and compositing tool commonly used by motion graphic designers.

ANIMATIC
> A placeholder or preliminary rough animation.

BUMPER
> Originally mandated by the FCC to tell you that the following is a paid advertisement. Also functions as a separator that identifies a network and as a separator between programming and nonprogramming.

COMPOSITING
> Superimposing multiple layers of video or film.

DESKTOP TOOLS
> Digital tools used for the production of video and audio in a personal-computer environment.

FLAME (DISCREET LOGIC)
> A high-end tool used for compositing and memory-intensive animation and special effects; usually found in a posthouse.

GRID
> Programming guide for cable or interface for satellite programming.

HDTV
> High-definition television.

HENRY (QUANTEL)
> A high-end real-time compositing and animation tool.

ID
> A short branding showpiece for a network or channel.

INTERSTITIAL
> Short original content that educates and/or entertains, used as a between-show separator.

MATTE
> A mask that defines an area of an image.

MENU
> Schedule of upcoming programming.

MOTION CONTROL
> A process through which a camera, dolly, and objects being photographed can be guided by a computer to perform repeatable movements necessary for a variety of special effects.

MULTIPLEXING
> The process of splitting one channel into multiple channels, and in many cases, into subbrands.

NEXT-ON
> A separator aired directly before a show to announce it.

OFF-THE-SHELF TOOLS
> Noncustomized, commercially available consumer-level hardware and software.

OPTICAL PRINTER
> Used to take multiple film elements, align them, and rephotograph them as a new piece of film; used in film titles to transfer graphics to film.

POSTHOUSE OR POSTPRODUCTION STUDIO
> A company that specializes in the production and technical tools, equipment, and expertise needed for production services in the film and video industry.

PROMO
> Short for promotion, a network or channel advertisement for a program.

STORYBOARDS
> A series of drawings that visually breaks down scenes, shot by shot, as envisioned by the director.

TRAILER
> A short preview or advertisement for an upcoming or currently running film, shown before the feature presentation in a theater or on home-entertainment mediums.

DIRECTORY

3 RING CIRCUS
1857 Taft Avenue
Hollywood, CA 90028

THE ATTIK
520 Broadway, 4th Floor
New York, NY 10012
www.theattik.com

**BALSMEYER
AND EVERETT**
495 West 15th Street
New York, NY 10011
www.balsmeyer-everett.com

**BRIAN DIECKS
DESIGN, INC.**
530 Broadway, 9th Floor
New York, NY 10012
www.briandiecksdesign.com

BUREAU
508 West 26th Street #9B
New York, NY 10001
www.bureau-
international.com

CHAMPION
3207 Glendale Boulevard
Los Angeles, CA 90039

FUEL, INC.
1914 Main Street
Santa Monica, CA 90405
www.fueldesign.com

GLOBAL JAPAN
145 West 45th Street
New York, NY 10036

HATMAKER
63 Pleasant Street
Watertown, MA 02472
www.hatmaker.com

LAMBIE-NAIRN
Greencoat House
15 Francis Street
London
SW1P1DH
United Kingdom
www.thebrandunion.co.uk

MARGO CHASE DESIGN
2255 Bancroft Avenue
Los Angeles, CA 90039
www.margochase.com

PMcD DESIGN
81 Franklin Street, 2nd Floor
New York, NY 10013
www.pmcddesign.com

POD DESIGN
2 Vine Street
Lexington, MA 02420
www.poddesign.com

yU + co.
1040 N. Las Palmas Avenue
Building 9
Hollywood, CA 90038
www.yuco.com

MTV LATIN AMERICA
1111 Lincoln Road, 6th Floor
Miami Beach, FL 33139
www.mtvla.com

LEE HUNT ASSOCIATES
11 Beach Street, Penthouse
New York, NY 10013
www.leehunt.com

VELVET MEDIENDESIGN
Osterwald Sta
1080805
Munich, Germany
www.velvet.de

PITTARD SULLIVAN
3535 Hayden Avenue
Culver City, CA 90232
www.pittardsullivan.com

**R/GREENBERG
ASSOCIATES**
350 West 59th Street
New York, NY 10018
www.rga.com

ACKNOWLEDGMENTS

This book would not have been produced without the enormous help of my wife Elizabeth Curran, my partner in life. Credit and thanks go to project manager Ellen Westbrook for her patience and insight, Madeline Perri, Shawna Mullen, Cathy Kelley, Jonathan Ambar, Winnie Prentiss, and everybody at Rockport who was involved with the development of this book. Thanks also to my friends at Hatmaker, especially Austin Wallender, Chris Goveia, Wendy Slate, and Tony Poillucci, for their help at the beginning of this project. A special thanks to Irv and Iris Schwartz, for their support and encouragement.

And finally, a sincere thanks to all of the many individuals from the firms featured in this book who helped to supply project briefs, images, credits and clearances, to the firm principals who found time in their busy schedules to be interviewed, and to all of the talented individuals who contributed to creating the outstanding designs featured in this book.